0:01

ISBN13: 978-1-933060-22-4
ISBN: 1-933060-22-0

ESPN books are available for special promotions and premiums. For details contact Michael Rentas, Assistant Director, Inventory Operations, Hyperion, 77 West 66th Street, 11th floor, New York, New York 10023, or call 212-456-0133.

FIRST EDITION

10 9 8 7 6 5 4 3 2 1

0:01

PARTING SHOTS FROM THE WORLD OF SPORTS

EDITED BY STEVE WULF

FOREWORD BY MIKE GREENBERG

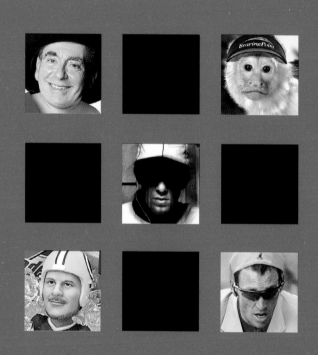

CONTENTS

THEY SAY A PICTURE IS WORTH A THOUSAND WORDS.

Goes to show you how little they know.

There is no limit to the number of words a picture can be worth. It just has to be the right picture. The world of sports gives us that picture all the time. It is the kid catching the foul ball in the stands, or the mother covering her eyes when her son gets tackled, or the football player whose uniform is caked with dirt and soaked with blood—his own and others'—as the final seconds tick off a clock above his shoulder.

How many words are those pictures worth?

Do you remember when Michael Jordan collapsed on the floor in the locker room, unwilling to let go of the ball, when the Bulls won the championship on Father's Day after his father's tragic death? There simply aren't enough words in the English language to tell that story, and even if there were, no one is eloquent enough to write them.

Most of us learn sports from pictures. I wasn't there when Willie Mays robbed Vic Wertz, or when Muhammad Ali knocked out Sonny Liston, or when John Havlicek stole the ball. But I've seen them all. I love those images.

They are the time capsules of sports. They are the way my kids will know what it looked like when Jordan scored over Craig Ehlo, and when Buster Douglas KO'd Mike Tyson, and when the Olympic hockey team made us all believe in miracles.

So I suppose there isn't any way to figure out how many words the pictures in this book are worth. These are not your classic sports photographs. Part photo, part art, part theater, they wink at a world we sometimes take too seriously. In the best 0:01s, like Joe Paterno in the middle of *It's a Wonderful Life*, or Frank Robinson crossing the Delaware, you find yourself in a place where reality and imagination come together. And if, perchance, you look hard enough—yes, I'm talking to you now, Golic—you may be able to learn everything you need to know about the past decade in sports.

Each of these pictures tells a story, and all of them together tell the story of a generation in sports. To me, that's worth a whole lot.

-MIKE GREENBERG

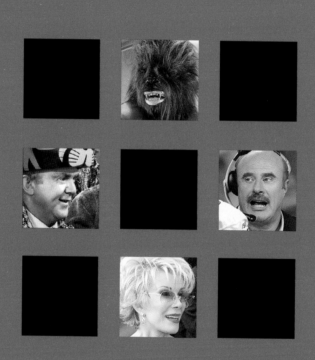

INTRODUCTION

WHAT DOES 0:01 MEAN?

Quite literally, it's the last second. For *ESPN The Magazine,* 0:01 is what we also call the back page, our last chance to visually comment on, poke fun at, sum up, or just get silly about matters of sports. It's sometimes holiday-oriented, like having Joe Paterno stand in for George Bailey in *It's a Wonderful Life*, or putting Terrell Owens at the head of an empty Thanksgiving table. It could be a Red Sox fan raking leaves in the shape of a B, or an NFL ref reviewing a kickoff involving Larry, Moe, and Curly. It's our biweekly parting shot, an opportunity to put a new spin on a world we love. Most of all, 0:01 is an attempt to leave readers with a smile.

Ironically enough, 0:01 was one of the first ideas we had when we created *ESPN The Magazine*

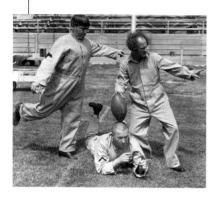

nine years ago. We were juggling a lot of lightbulbs back then, but we didn't drop this one. Truth be told, those early 0:01s missed as often as they hit.

Our criteria were fairly loose—it just had to be visual—and so one issue we would do something historical, like dress up the first NFL No. 1 pick, Jay Berwanger, in his old uniform; the next issue something cutesy, like a painting of "Mount Crushmore"; the next issue something Jordanesque (we were obsessed with his Airness our first year); the next … well, looking back on some of them, what the hell were we thinking?

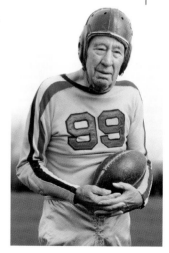

Eventually, we discovered that readers preferred our more humorous efforts to our serious ones. And we began using photo illustrator Aaron Goodman more and more. Aaron could turn one of our goofy ideas into a work of art in a matter of days. Case in point: "Four Scores and Seven Beers Ago…" (The 2002 original appears inside. The version on the front cover is new and improved.)

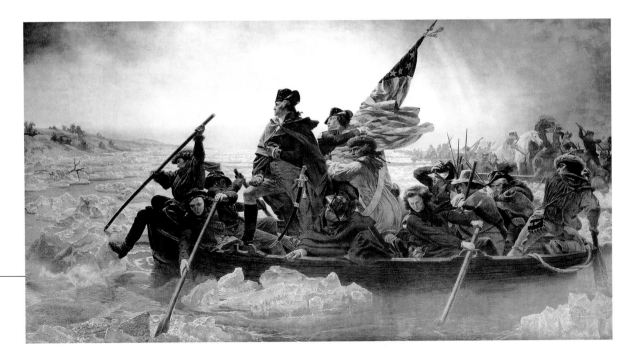

Then there was "The Crossing," his other Hail to the Chief, in which Frank Robinson plays the part of George Washington. Every other Tuesday, following the Sunday close of *The Magazine*, a small group meets for what we call Uh-Oh One, the initial idea conference for the next 0:01. On this particular Tuesday in June of 2005, the Washington Nationals were in first place in the National League East, and the next issue date was the Fourth of July. What if we were to put their field general in the famous tableau of General Washington crossing the Delaware? We Googled the Emanuel Gottlieb Leutze painting and saw at once the possibilities and impossibilities. Great idea, but could we do it in the seven days we're usually given to produce the back page?

Aaron rose to the occasion. Or rather, he lowered a replica of Washington's captain's gig into the Hudson, hired models of similar body type, bought uniforms, combed through countless head shots of various Nationals, and rented a really big flag. He also tolerated some of our last-minute suggestions, one of which was to put the old Expos mascot, Youppi, in the water.

The resulting image was astounding, but then, we're an easy audience. The proof in the pudding was when we got word that Frank Robinson wanted a bunch of prints to give to people. As the Nats can tell you, Robby is not an easy man to please. We did, however, anger *les Québécois*, who considered the submersion of Youppi a sacrilege.

Actually, that was Youppi's third appearance in an 0:01—he (it?) had a Christmas stocking in "Nick Knacks" and a prominent role in a fake Expos calendar we called "Homeless Stand." We often gravitate toward characters with oversize heads, which is why we've featured Billy the Marlin twice and Barry the Giant four times.

People used to ask us how we came up with 0:01

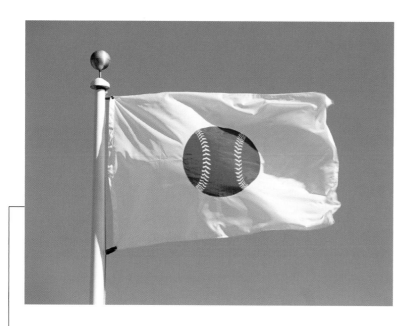

WE OFTEN GRAVITATE
TOWARD CHARACTERS
WITH OVERSIZE HEADS.

ideas—until we started to explain the process, which bored them to tears. So we'll keep it short. Picture three or four editor types, a page designer, and a photo editor sitting around a monumentally messy office (mine), complete with seats from the Vet in Philadelphia and Memorial Stadium in Baltimore. The Merry Band bats around and mocks various concepts having to do with the latest pop culture phenomenon or an upcoming holiday or a sports figure in the news. We stay put until the eureka moment, sometimes three minutes into the meeting, sometimes 60, sometimes until an adjournment 'til the next day is requested. Once we have the idea, we call Aaron, and he sends us back a sketch of, say, a monkey.

Every so often, we lose an 0:01 at the last second. We were about to close "Greensleeves," in which Tiger Woods puts a Green Jacket on Tiger Woods, when we got word that he might have to withdraw from the 2006 Masters because of his father's illness. With roughly an hour until press time, we created a new flag for Japan in celebration of its victory in the World Baseball Classic ("Lost in Translation"). And sometimes we make a mistake. For "Dr. Philly," we put Dr. Phil in a head-

set between TO and Donovan McNabb. What we didn't take into account is that, at 6'4", Phil is taller than both of them.

In our more sentimental moments, we often talked about putting a book of 0:01s together. So when we were finally given the chance, the hardest part was determining which of our favorites we would have to leave out. Call it Nomar and Mia's Choice—we had to ding either their TV sitcom ("A Very Special Episode") or their waiting in line for *Revenge of the Sith* ("Playing Wookie"). On the following pages, you'll find the 0:01s divided into various categories: Seasons, Zoology, Classics, Main Events, Popcorn.

As an added treat, we even came up with some 0:00s—back pages we wish we had created at the time or couldn't run for some reason.

Like taste.

-STEVE WULF

SEASONS

You can often set your calendar by 0:01.
Holidays are big—especially Halloween.

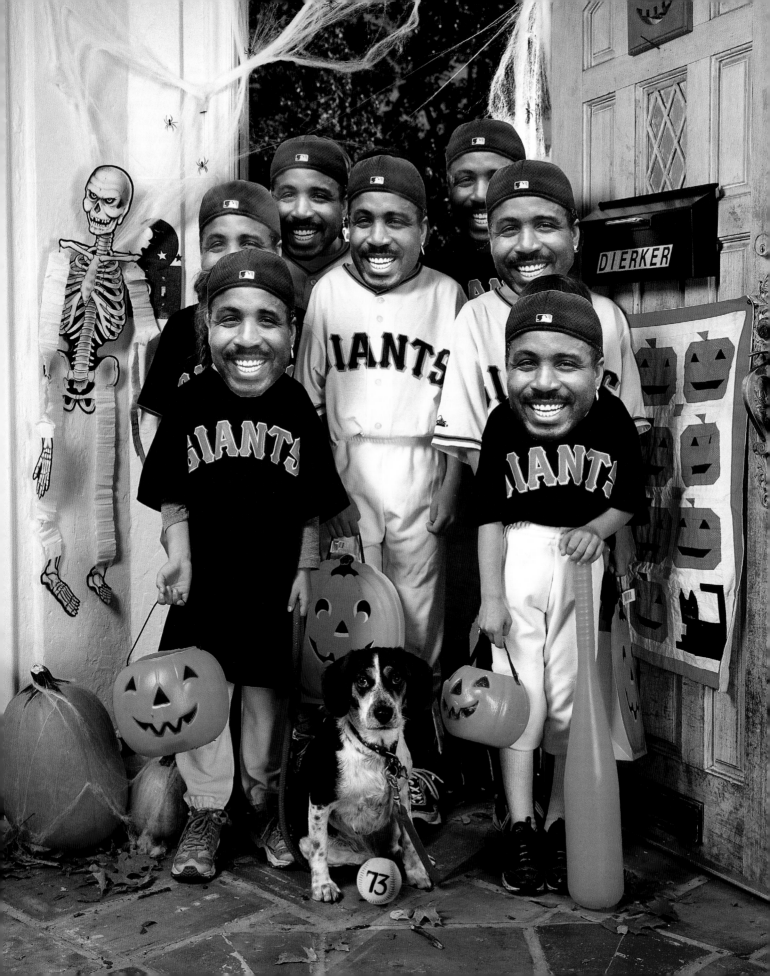

MONSTER SEASON

OCTOBER 29, 2001

Barry Bonds had just hit 73 homers, so some masking agents were found for him. Note the name on the mailbox: Houston Astros manager Larry Dierker steadfastly refused to pitch to him.

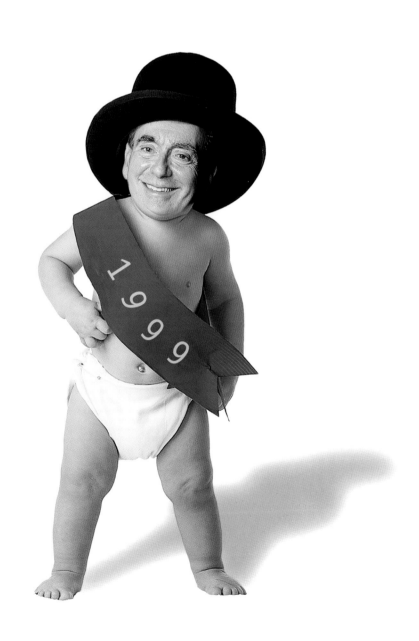

DIAPER DANDY

JANUARY 11, 1999

Who better to play a New Year's baby than the ESPN college hoops analyst who coined the title phrase?

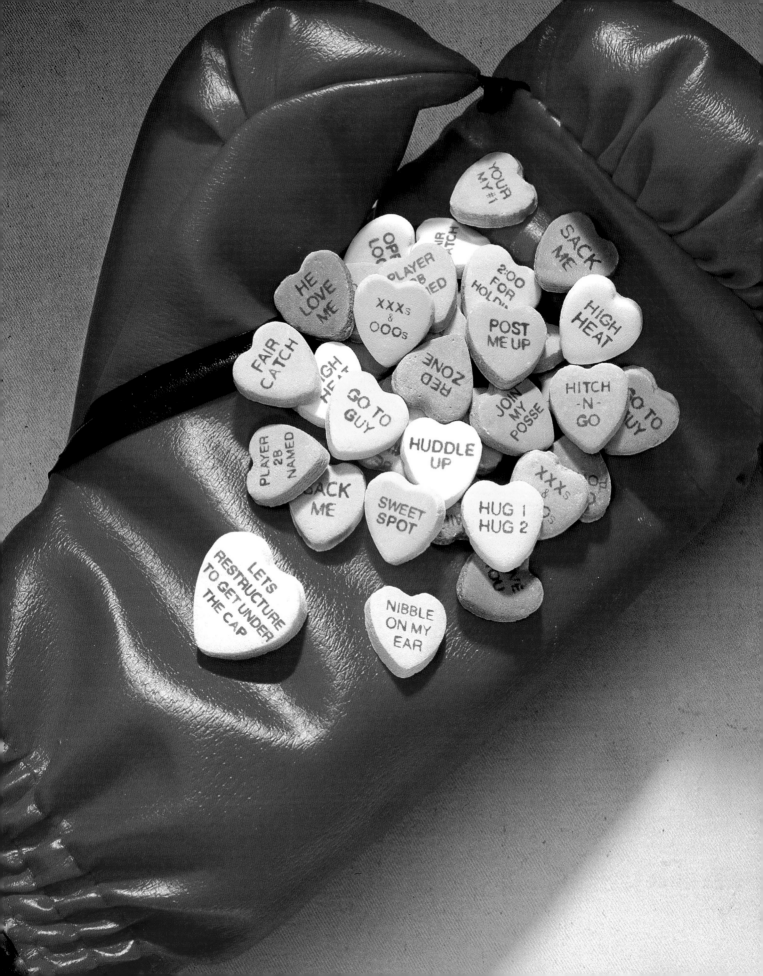

SWEET SCIENCE

FEBRUARY 18, 2002

A little eye candy for Valentine's Day.

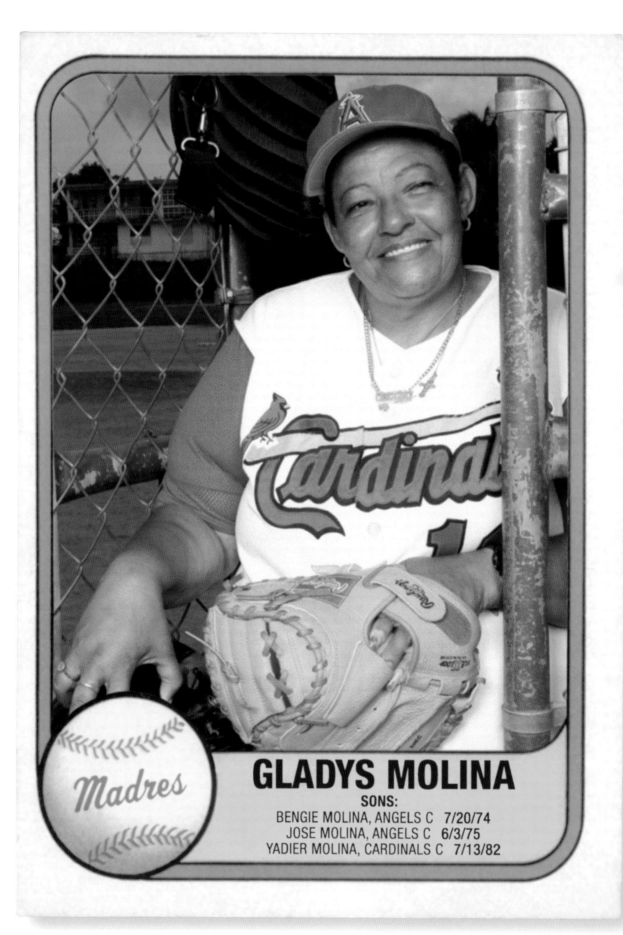

GLADYS MOLINA
SONS:
BENGIE MOLINA, ANGELS C 7/20/74
JOSE MOLINA, ANGELS C 6/3/75
YADIER MOLINA, CARDINALS C 7/13/82

MOTHER'S DAY CARD

MAY 9, 2005

A card to remember Mama Gladys Molina, who has three sons, all catchers, in the majors: Bengie, Jose, and Yadier.

FATHER'S DAY TIES

JUNE 10, 2002

Rack 'em up (from left): quarterback Ty Detmer, *Caddyshack*'s Ty Webb, Hall of Famer Ty Cobb, the famous Michigan State-Notre Dame 10-10 tie from 1966, hockey goon Tie Domi, and golf wunderkind Ty Tryon.

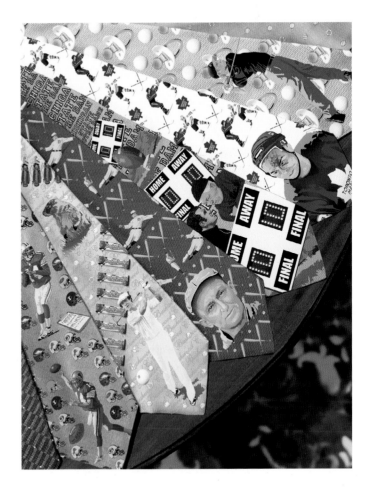

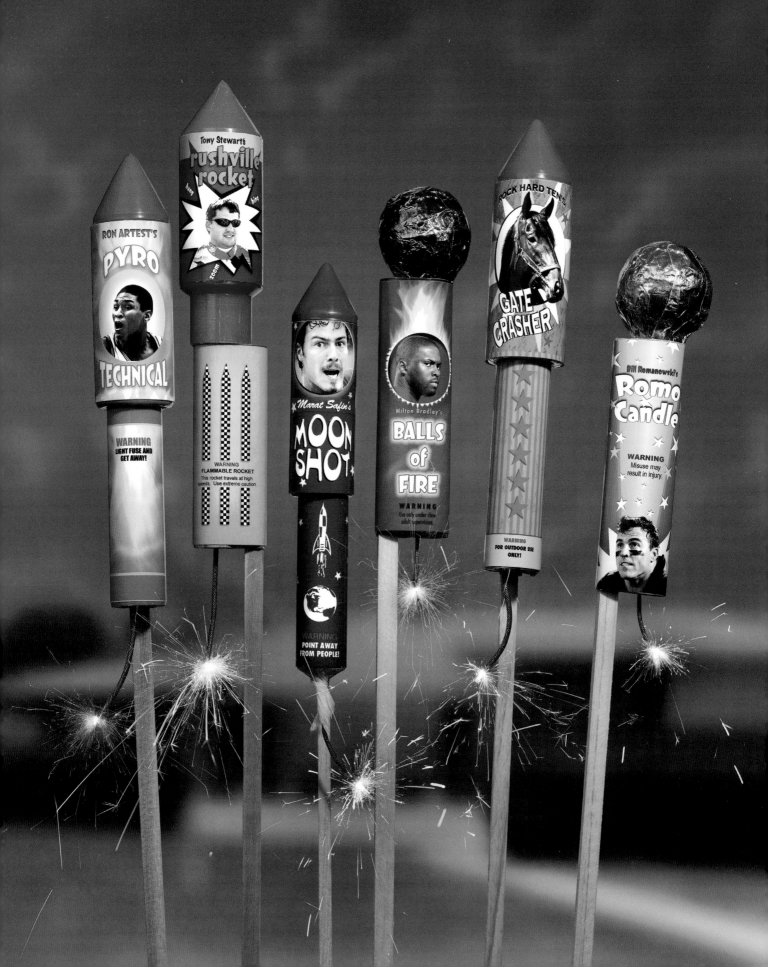

FIREWORKS DISPLAY

JULY 5, 2004

There were more than a few combustible athletes in the news, including hoopster Ron Artest, driver Tony Stewart, tennis star Marat Safin (fresh off dropping his shorts during a tournament), outfielder Milton Bradley, fractious thoroughbred Rock Hard Ten, and linebacker Bill Romanowski.

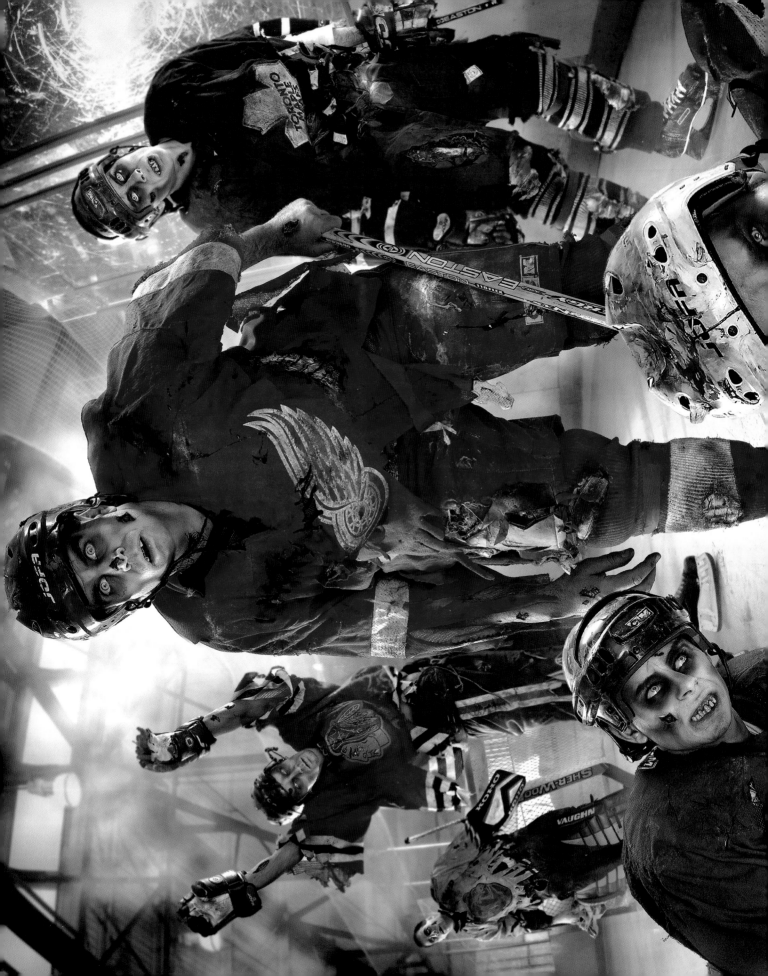

NATIONAL HORROR LEAGUE

OCTOBER 25, 2004

The NHL wasn't too happy when its players were turned into zombies, but hockey fans weren't too happy either about the Season of the Living Dead.

TRICKED

NOVEMBER 7, 2005

Imagine what would happen if trick-or-treaters found out that Rafael Palmeiro, who tested positive for steroids shortly after getting his 3,000th hit, was living in the neighborhood. The knife in the Tejada shirt is a reference to Palmeiro's trying to shift the blame to Miguel Tejada for giving him B12 vitamins.

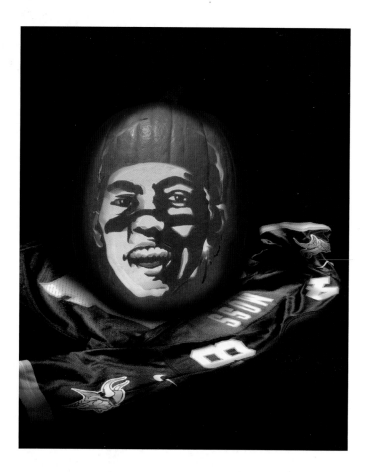

SCARY GOOD

OCTOBER 27, 2003

He struck fear into the hearts of defensive backs, so a pumpkin carving of Minnesota Vikings receiver Randy Moss was commissioned.

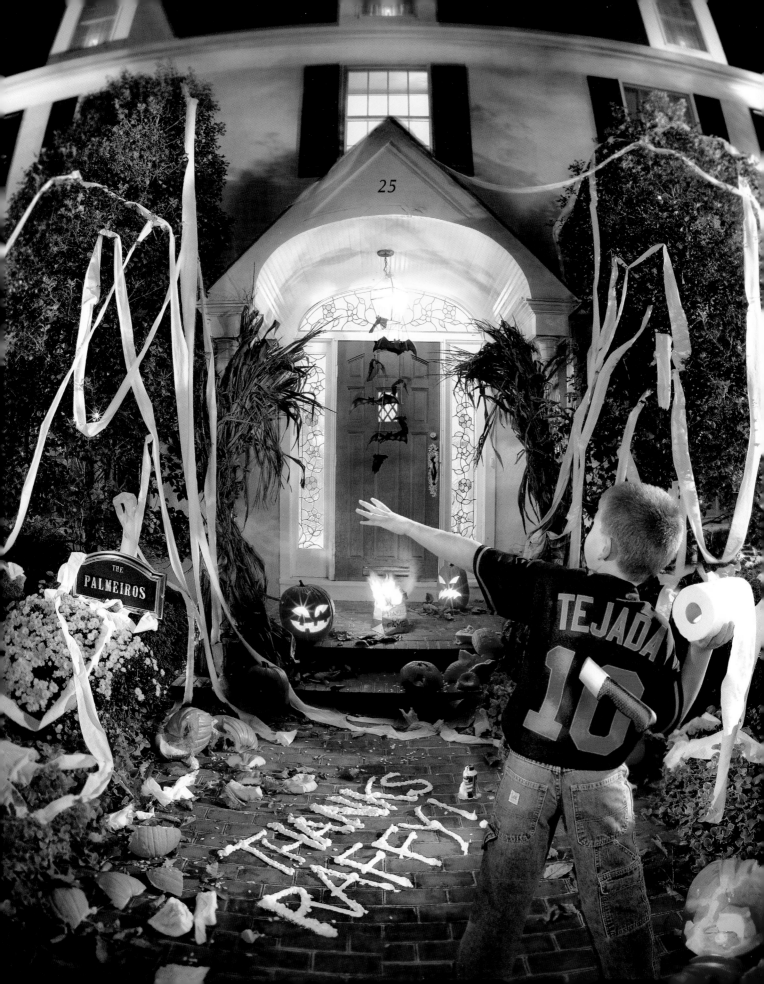

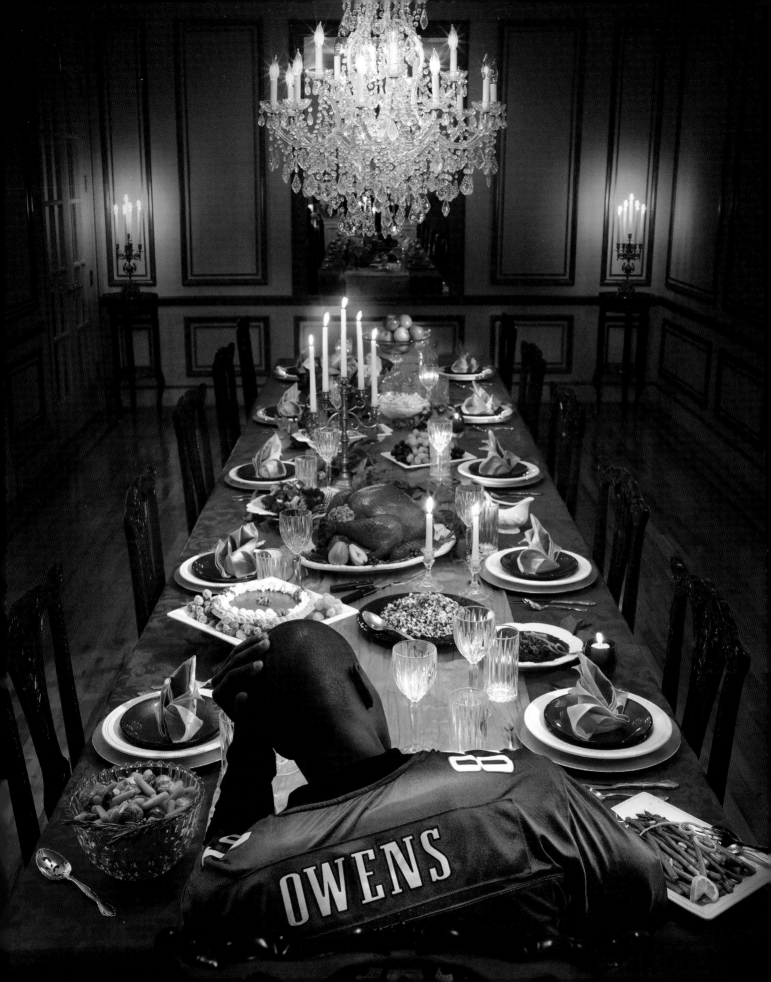

PASS THE GRAVY

DECEMBER 5, 2005

Terrell Owens nearly brought a Super Bowl
XXXIX trophy to the Philadelphia Eagles.
But the next season, the wide receiver
brought nothing but trouble. By
Thanksgiving, TO was all by himself.

HOLIDAY RAP

DECEMBER 6, 2004

The idea for this CD came when volatile Indiana Pacer Ron Artest took a mini-sabbatical to promote the new record he was producing. Two days after the page closed, Artest went into the stands and ignited the Malice at Auburn Hills. That lent new meanings to tracks 2, 3, 4, and 13.

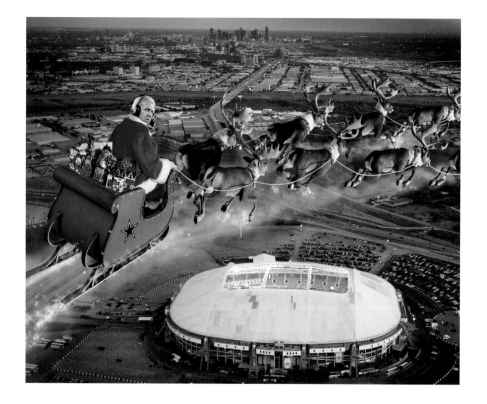

COWBOY UP

DECEMBER 22, 2003

Bill Parcells wasn't exactly jolly, but he did have the right build, and he had delivered a contender to Dallas. The alternate title: X's and Hos.

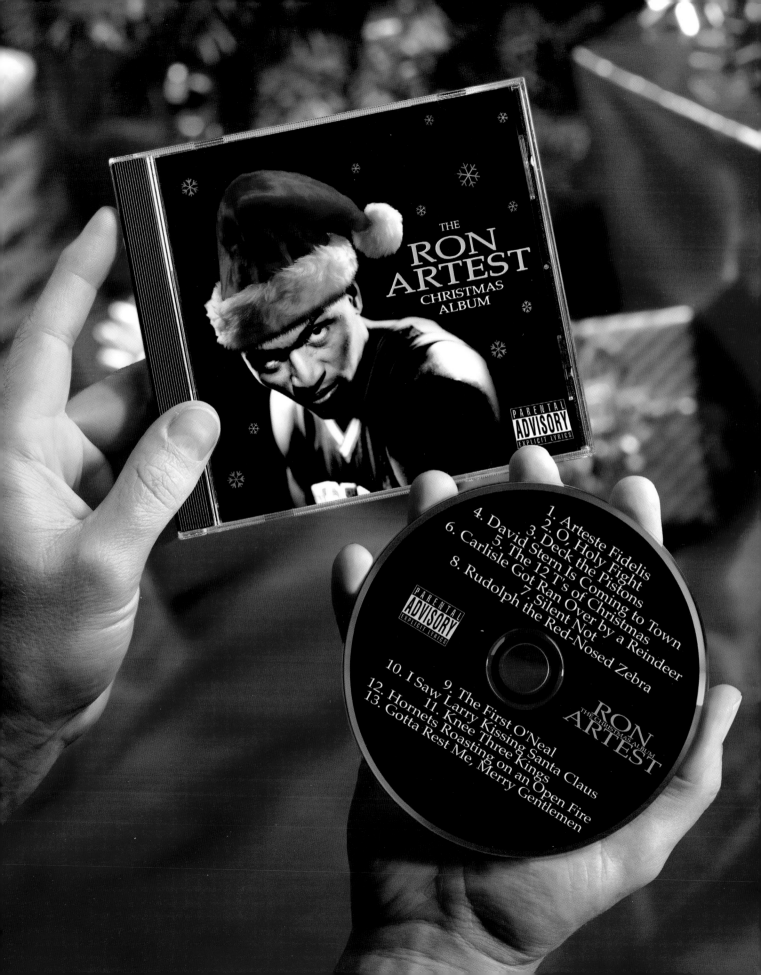

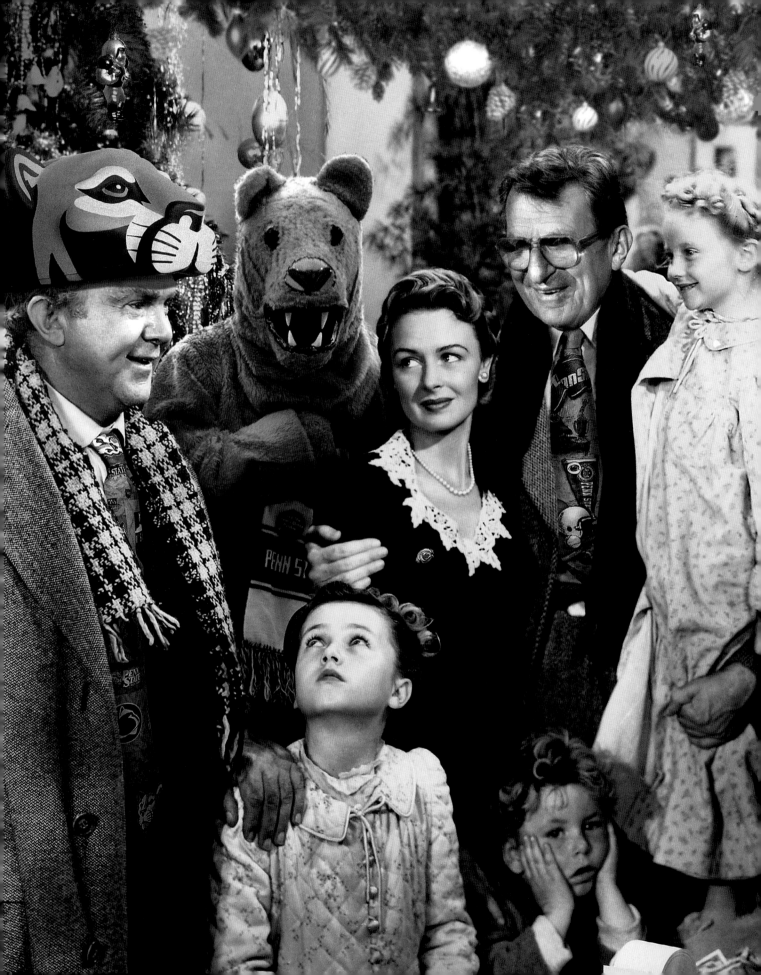

IT'S A
WONDERFUL LIFE

DECEMBER 19, 2005

After a season in which Penn State football coach Joe Paterno found redemption, it seemed only natural to reimagine him as George Bailey from the classic holiday movie. (Note how the richest man in Happy Valley is surrounded by Nittany Lions paraphernalia.)

TURN OF THE CENTURY

DECEMBER 27, 1999

Out with the old—Michael, Hank, Johnny, Wayne, Billie Jean, Jack—in with the new: Vince, Ken, Peyton, Jaromir, Serena, Tiger.

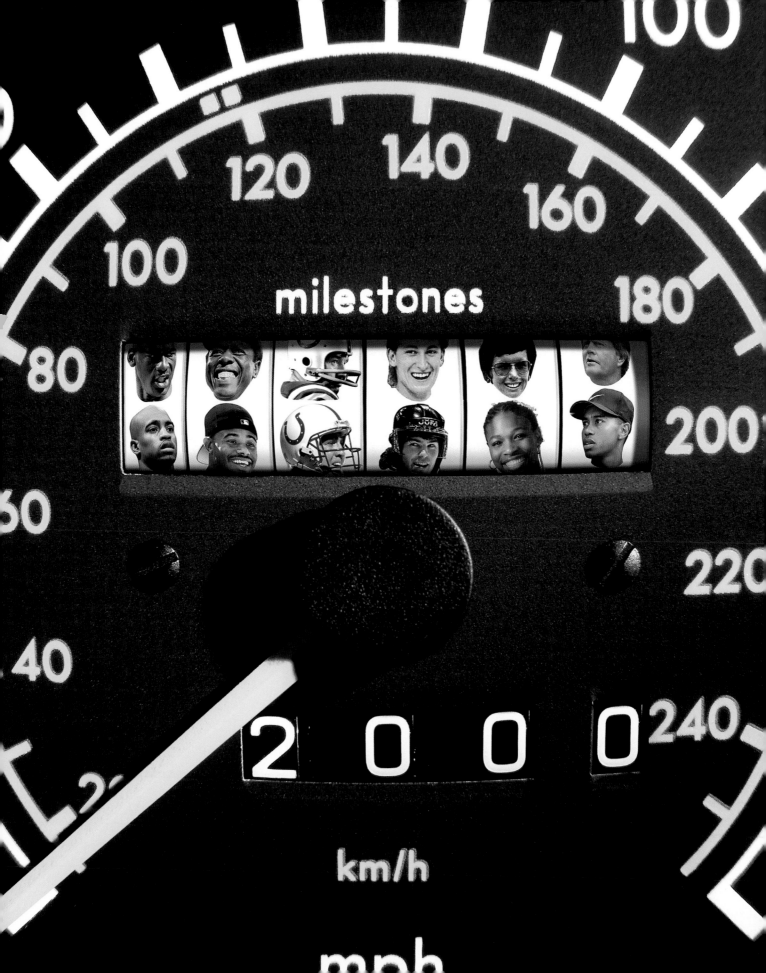

ZOOLOGY

No animals were harmed in the making of these
0:01s. Wait, that's not exactly true—some bugs
died. On the other hand, a squirrel was released.

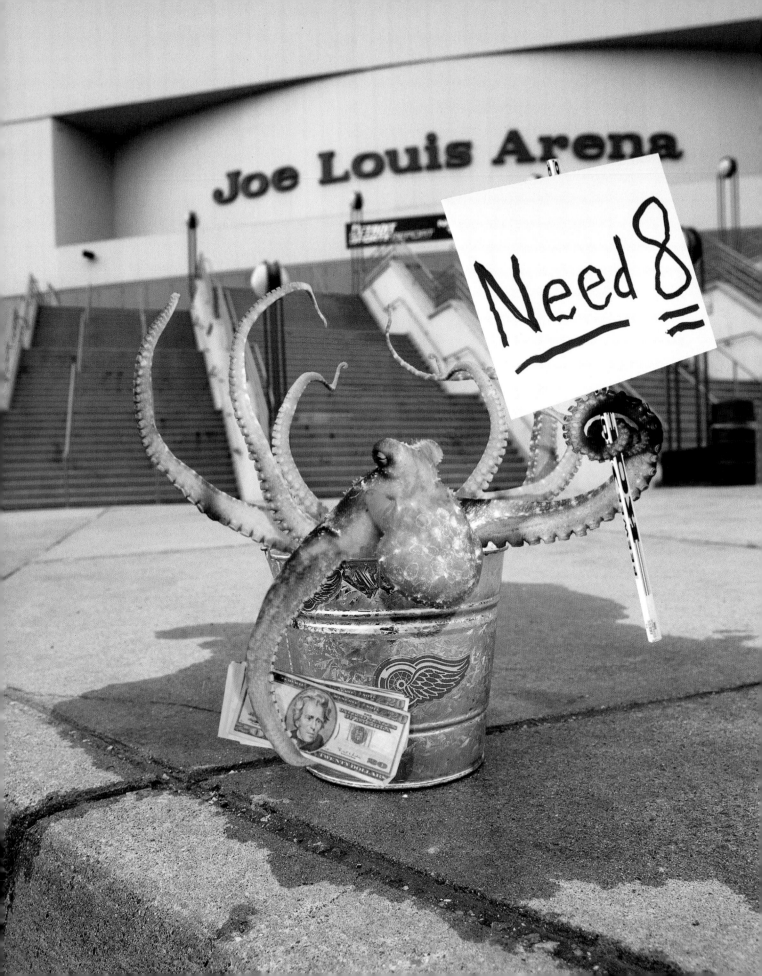

WELL ARMED

APRIL 29, 2002

The tradition began in 1952, when Red Wings
fans from a Detroit fish shop threw an octopus
on the ice to symbolize the eight wins the
team would need to claim the Stanley Cup.
With the Wings headed for another Cup, the
octopus took on a life of its own.

TIN CUP

MAY 10, 2004

Once Phil Mickelson won the Masters, the major primate he'd been carrying around with him was out of a job. Word has it he's now working for Sergio Garcia.

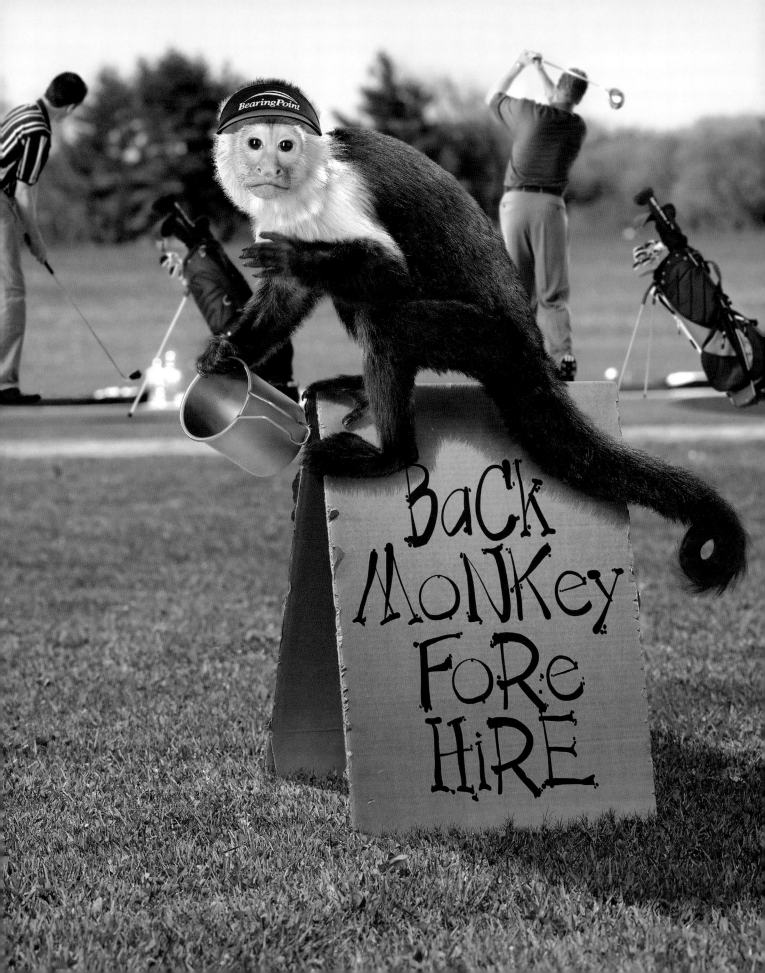

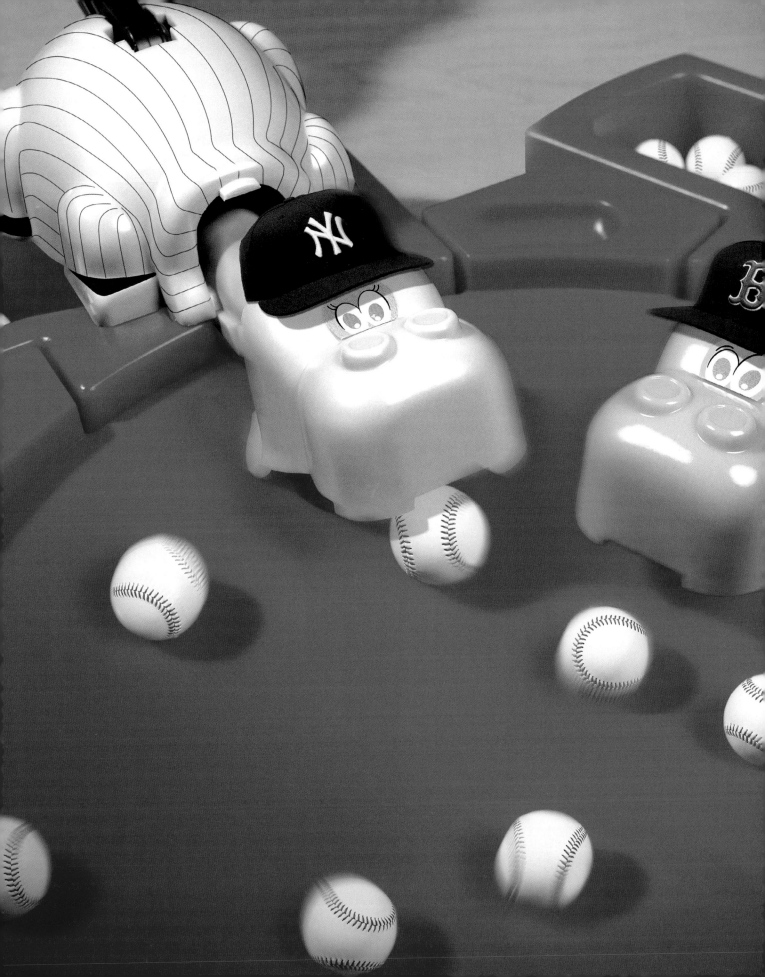

HUNGRY
HUNGRY HIPPOS

JANUARY 19, 2004

The Yankees and Red Sox were frantically
devouring every free agent in sight, which
brought to mind a childhood favorite.

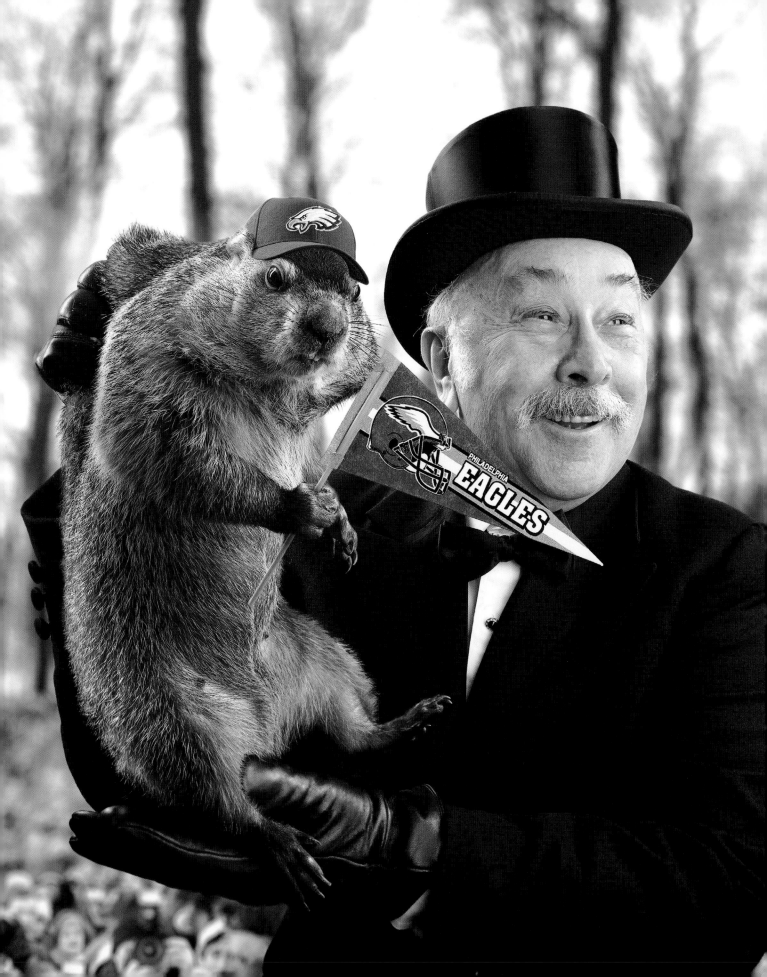

PUNXSUTAWNEY
PHILLY

FEBRUARY 14, 2005

Groundhog Day came four days before Super
Bowl XXXIX. But then Phil saw the shadow of
the New England Patriots, which meant another
year without a championship.

GOBBLE, GOBBLE

NOVEMBER 22, 2004

Some turkeys in jerseys spoke of
the short end of the wishbone.

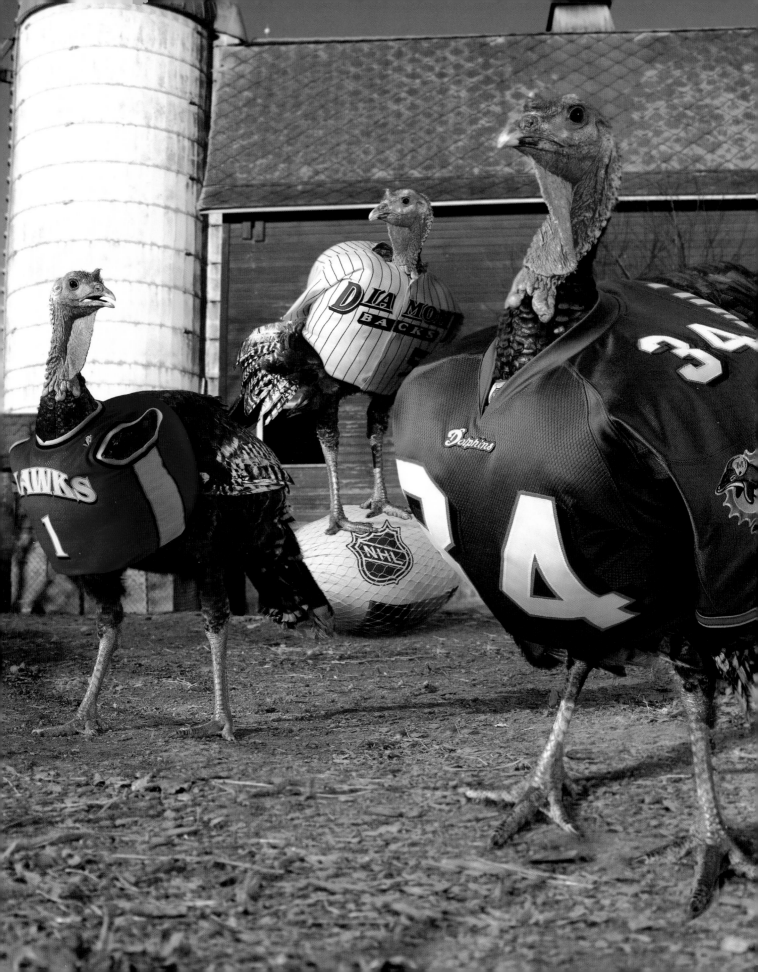

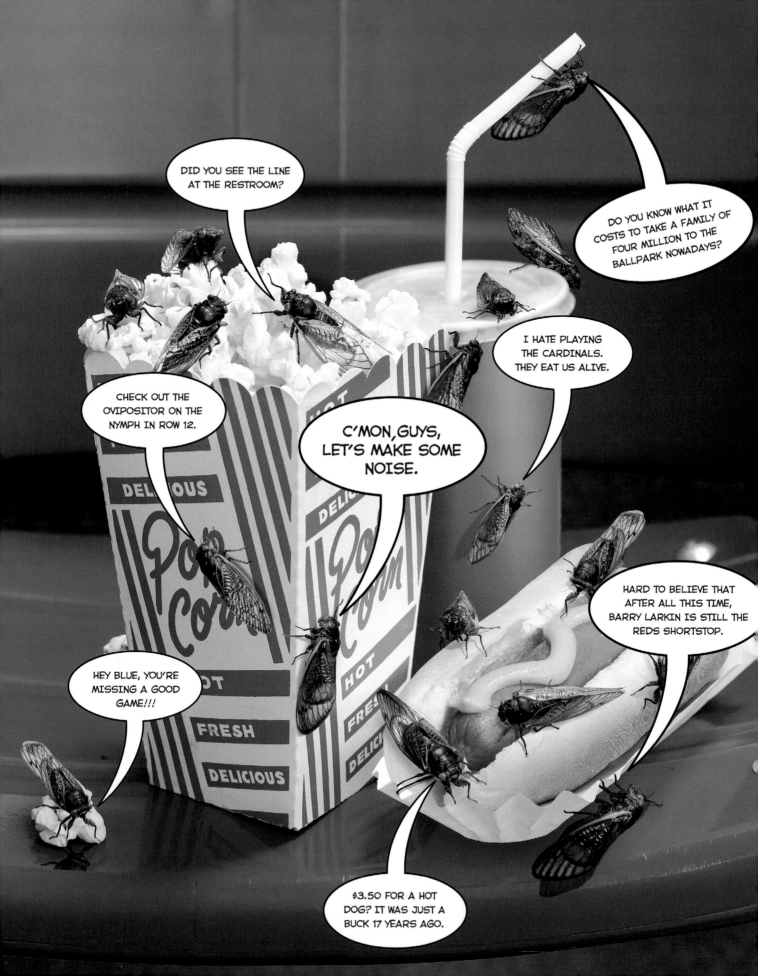

BACK, BACK, BACK

JUNE 21, 2004

After 17 years—then the span of Barry Larkin's playing career—the cicadas were back in full force in the eastern United States. Aaron Goodman captured dozens of them outside of Princeton, New Jersey, but by the time he got back to New York City for the shoot, all but two had perished.

GREEN MONSTER

JULY 7, 2003

The seats atop the leftfield wall at Fenway were still a novelty, and *Hulk* had just hit theaters. Hulk, Green Monster—get it?

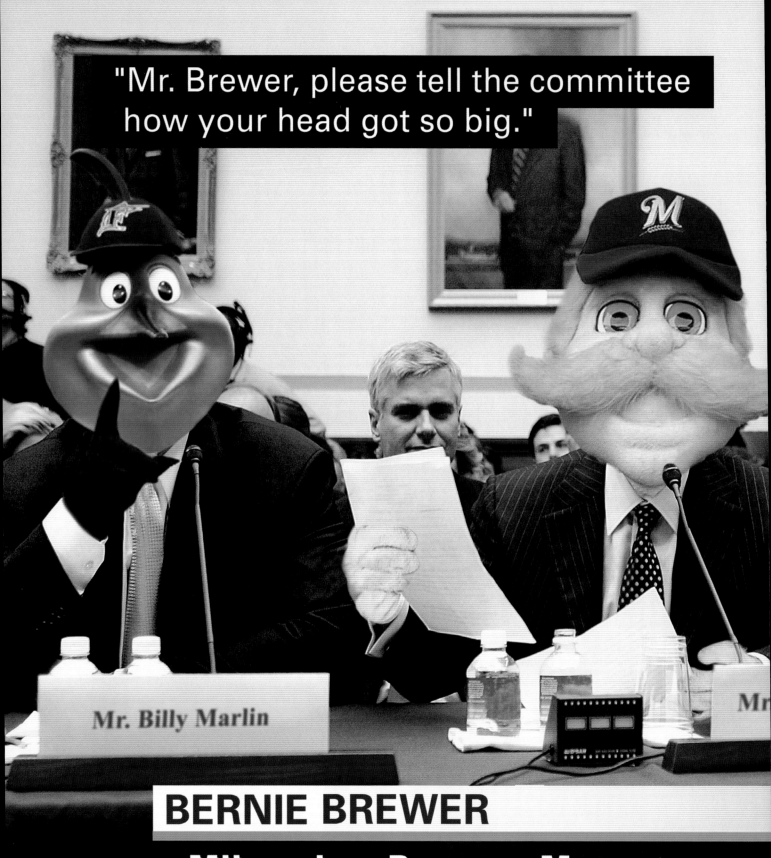

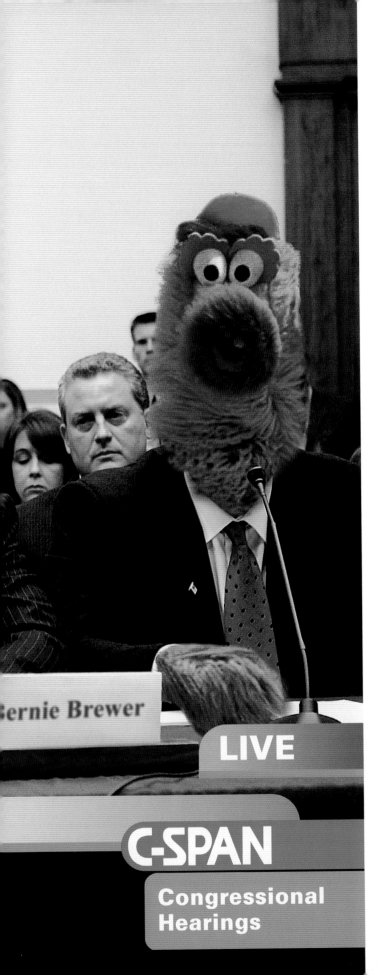

UNUSUAL SUSPECTS

APRIL 11, 2005

As if the congressional hearings into steroid use in baseball weren't comical enough …

BUSHY LEAGUER

JUNE 19, 2006

Every week or so, *SportsCenter* runs a highlight of a squirrel running onto a field. In fact, our furry friends were actually getting more play in 2006 than the Kansas City Royals. That's why this guy got the green light.

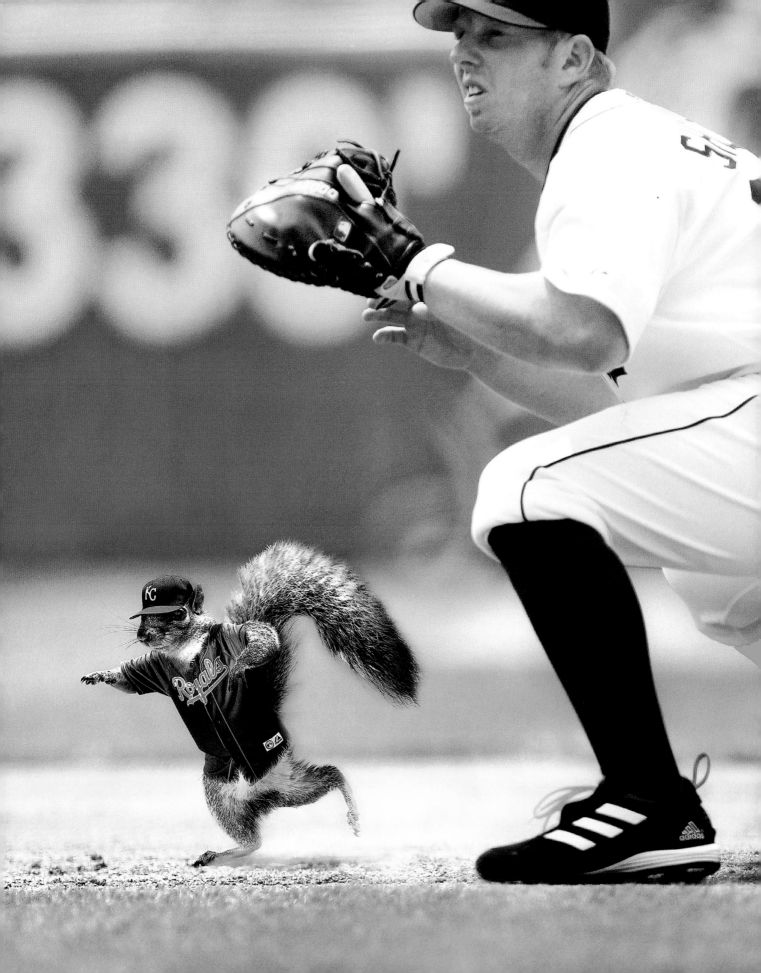

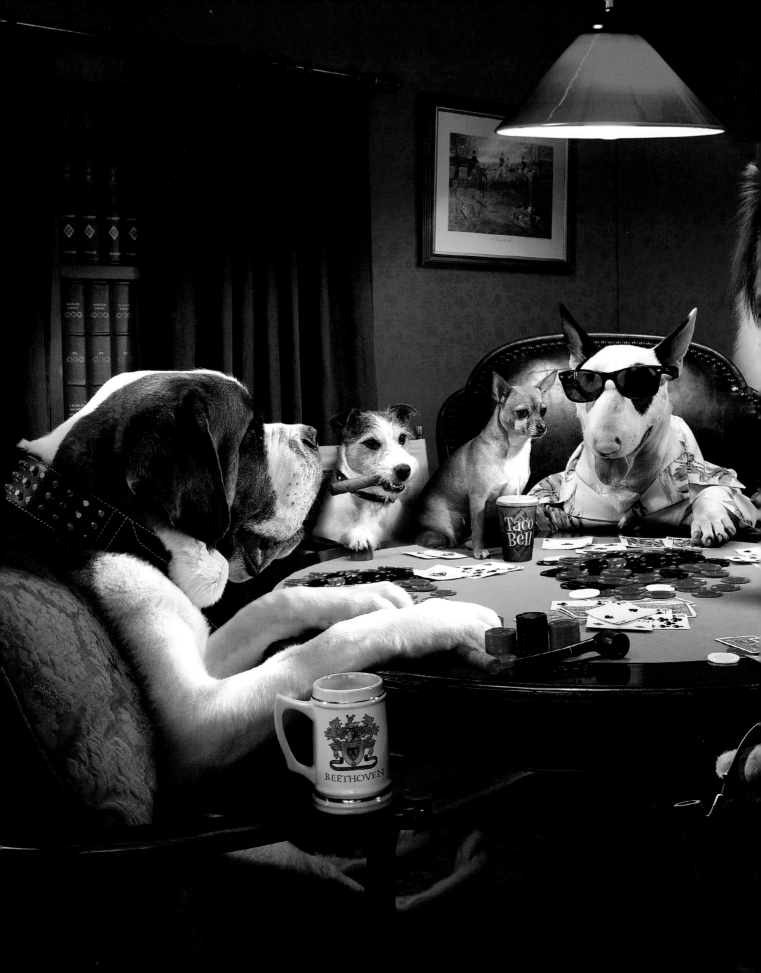

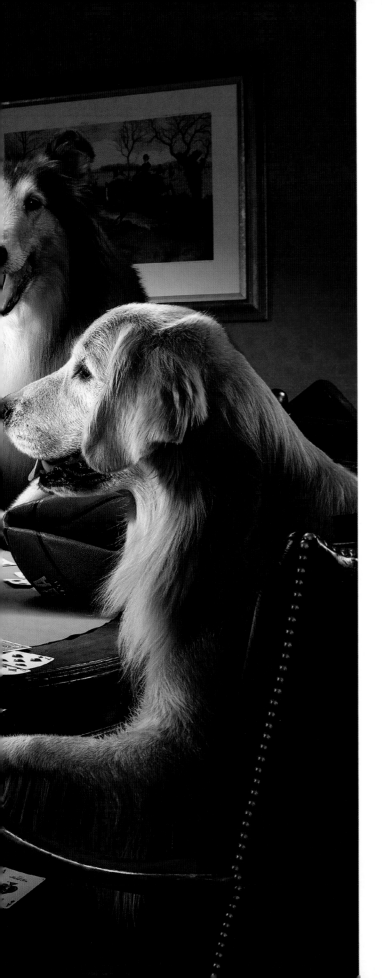

CELEBRITY DOGS
PLAYING POKER

JANUARY 17, 2005

By the end of 2004, poker—particularly celebrity poker—was all over the tube, so somebody needed to breed the craze with the classic kitsch painting. Ringers were found for (clockwise from left) Beethoven, Eddie (from *Frasier*), the Taco Bell Chihuahua, Spuds MacKenzie, Lassie, and Air Bud. All the dogs, by the way, were shot separately. They don't much like each other.

CLASSICS

Do these stand the test of time? Well,
they hold up past their issue dates.

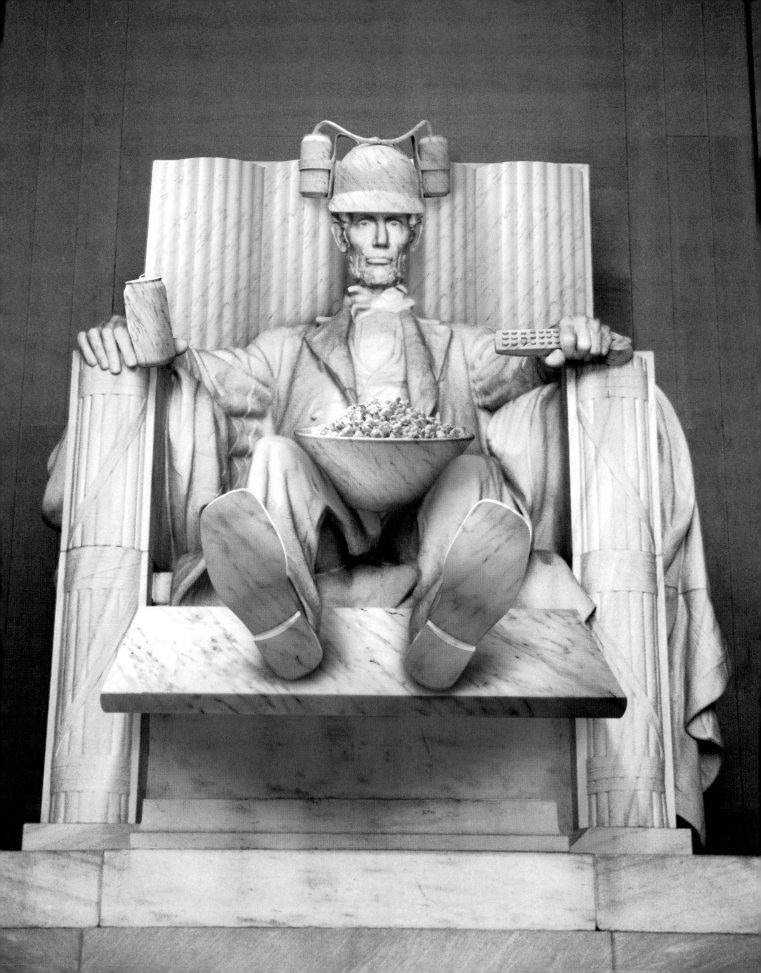

FOUR SCORES AND SEVEN BEERS AGO …

FEBRUARY 4, 2002

Lincoln was a huge Yankee fan.

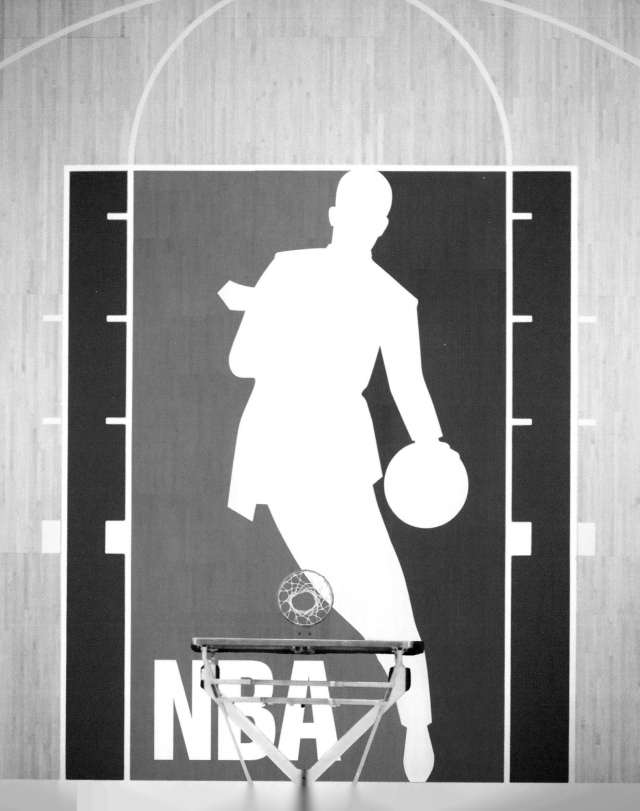

NATTY BASKETBALL ASSOCIATION

When the NBA instituted a new dress code for players in 2005, it seemed like the classic Jerry West logo could do with a little makeover as well.

’05 HOLE

MARCH 14, 2005

The last hopes for a shortened NHL season had just been dashed.

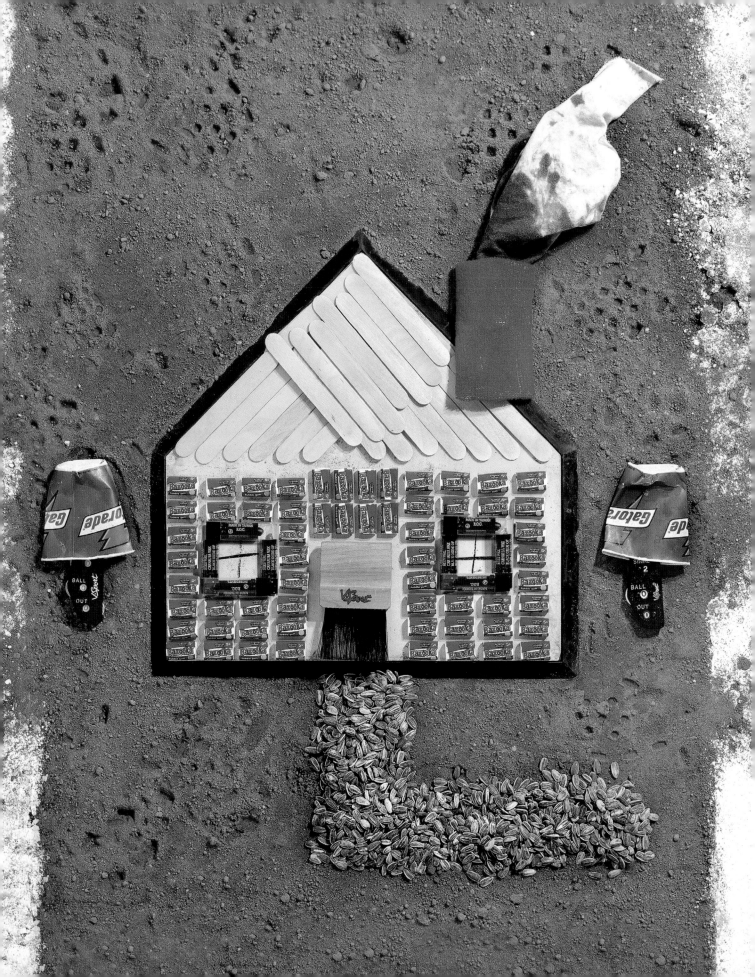

HOME SWEET HOME

APRIL 15, 2002

The plate was turned into a home using items that can be found in every clubhouse.

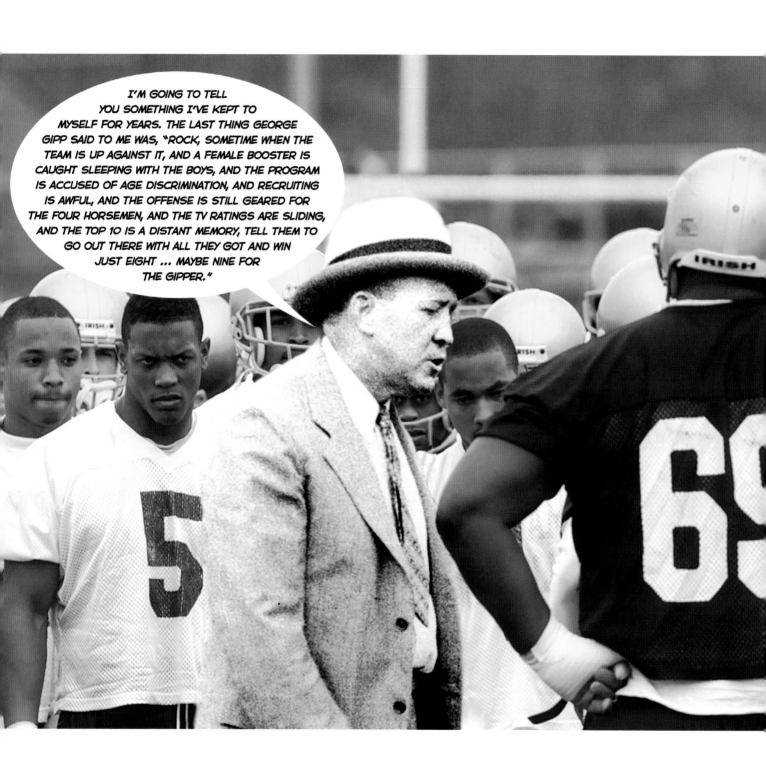

GIPPER 2000

AUGUST 21, 2000

If Knute Rockne had been brought back to revive the scandal-ridden Notre Dame football program, this might have been his speech.

dead \'ded\ adj 1: LIFELESS 2: DEATHLIKE, DEADLY 3: no longer active or functioning (a ~ battery)

dead·wood \-,wùd\ n 1: wood dead on the tree 2: useless personnel or material (a lot of ~ on the Tigers)

deal \'de(ə)l\ vb 1: DISTRIBUTE; esp: to distribute playing cards to players in game (dealt a bad hand) 2: TRADE (failed to ~ for a catcher who could hit) 3: to reach a state of acceptance (~ with more than 120 losses)

death·watch \'deth-,wäch\ n: a vigil kept over the dead or dying (a ~ maintained by the beat writers)

de·ba·cle \dē-'bä-kəl\ n [F debacle]: DISASTER, FAILURE, ROUT (biggest ~ in baseball history)

de·based \di-'basd\ vb 1: lowered in character, quality or value 2: colloq. picked off first, second or third in baseball

de·bat·able \di-'bā-tə-bəl\ adj open to dispute: QUESTIONABLE (it's ~ whether the Tigers are a major league team)

de·cay \di-'kā\ vb 1: to decline from a sound or prosperous condition 2: to cause or undergo decomposition (pained Kirk Gibson to see them ~ like that): ROT

de·ceive \di-'sēv\ vb 1: to cause to believe an untruth 2: to use or practice deceit: BEGUILE, BETRAY, DELUDE, MISLEAD (to ~ season ticket-holders)

de·cline \di-'klīn\ n 1: a gradual sinking and wasting away 2: a change to a lower state or level 3: the time when something is approaching its end (~ brought about by the barren farm system)

de·crease \'de-,krēs\ n 1: the process of decreasing 2: REDUCTION (a dramatic ~ in attendance)

de·crep·it \di-'kre-pət\ adj: broken down with age: WORN-OUT (the ~-looking swing of Bobby Higginson)

de·cry \di-'krī\ vb to express strong disapproval of (Mitch Albom couldn't help but ~ the direction of the club)

deep \'dēp\ adj 1: extending far down, back, within or outward (~ in the cellar) 2: difficult to understand; also: MYSTERIOUS, OBSCURE (~ reasons for continually starting Shane Halter) 3: INTENSE, PROFOUND (~ squat)

de·fang \(,)dē-'faŋ\ vb: to make harmless or less powerful: WEAKEN (did everything he could to ~ the franchise)

de·fea·sance \di-'fē-zən(t)s\ n 1: DEFEAT, OVERTHROW 2: a rendering null or void

de·feat \di-'fēt\ n 1: FRUSTRATION 2: an overthrow of an army in battle 3: loss of a contest (yet another ~ for the Tigers)

de·fec·tive \di-'fek-tiv\ adj: FAULTY, DEFICIENT (~ middle relief)

de·fense \di-'fen(t)s\ n 1: the act of defending: resistance against attack 2: a defending party, group or team 3: fielding, as in baseball (their inept outfield ~) — **de·fense·less** adj (SEE Dmitri Young)

de·fraud \di-'fród\ vb: CHEAT (accused of ~-ing Detroit voters)

de·funct \di-'fəŋkt\ adj: DEAD, EXTINCT (~ after 102 years)

de·gen·er·ate \di-'jen-rət\ adj: fallen or deteriorated from a former, higher, or normal condition

de·grad·ing \di-grā-diŋ\ adj: reduced from a higher to a lower rank or degree 2: DEBASED, CORRUPT (the ~ task of covering the Tigers)

dé·jà vu \,da-,zhä-'vü\ n (F., adj., already seen): the feeling that one has seen or heard something before (Ernie Harwell had a sense of ~, back to the '62 Mets)

de·ject·ed \di-'jek-təd\ adj: low in spirits: SAD (the manager's ~ countenance)

del·e·te·ri·ous \,de-lə-'ti-rē-əs\ adj: HARMFUL, NOXIOUS (slashing of payroll proved ~)

de·lin·quent \di-liŋ-kwənt\ adj 1: offending by neglect or violation of duty or of law 2: being overdue in payment

de·lu·sion·al \di-'lüzh-nəl\ adj: persistently believing in a false idea or notion (the ~ fan took his giant foam finger into Comerica Park)

de·mean \di-'mēn\ vb 1: to behave or conduct (oneself) usu. in a proper manner 2: DEGRADE, DEBASE

dejected

de·mer·it \di-'mer-ət\ n 1: FAULT 2: a mark placed against a person's record for some fault or offense (tried not to look at his 20th loss as a ~)

De·me·ter \di-'mē-tər\ n 1: the Greek goddess of agriculture 2: outfielder (Don) who drove in 80 runs for the '64 Tigers

de·mi·monde \'de-mi-,mänd\ n [F fr. demi- half + monde world] 1: a class of women on the fringes of respectable society supported by wealthy lovers 2: a group engaged in activity of doubtful legality or propriety (looked upon as the ~ of baseball)

de·mise \di-'mīz\ n 1: LEASE 2: transfer of sovereignty to a successor 3: DEATH 4: loss of status (the ~ of the once-proud franchise)

de·mol·ish \di-'mä-lish\ vb 1: to destroy by breaking apart: RAZE (first, they ~ Tiger Stadium, then they ~ the team) 2: SMASH 3: to put an end to

de·ni·al \di-'nī-(-ə)l\ n 1: a rejection of a request 2: refusal to admit the truth of a statement or charge (Dave Dombrowski acted as if he were in ~); also: assertion that something alleged is false

den·i·grate \'de-ni-,grāt\ vb: to cast aspersions on: DEFAME (continued to ~ Mike Ilitch)

de·nounce \di-'naùn(t)s\ vb 1: to pronounce esp. publicly to be blameworthy or evil 2: ACCUSE (continued to ~ Mike Ilitch)

dense \'den(t)s\ adj 1: marked by compactness or crowding together of parts: THICK (crowds no longer ~) 2: DULL, STUPID (Mike Ilitch couldn't be that ~)

De·troit \di-'troit\ city SE Mich. on Detroit River *pop.* 951,270 2: last place in the American League Central

LAST WORDS

SEPTEMBER 29, 2003

The Detroit Tigers were on their way to losing 119 games and redefining "deplorable."

UPON
FURTHER
REVIEW

FEBRUARY 13, 2006

NFL referees weren't having a good postseason in 2005, so it was time to check under their hoods. In order to avoid singling out any one zebra, an unused number was chosen. Luckily, the only one available was 13.

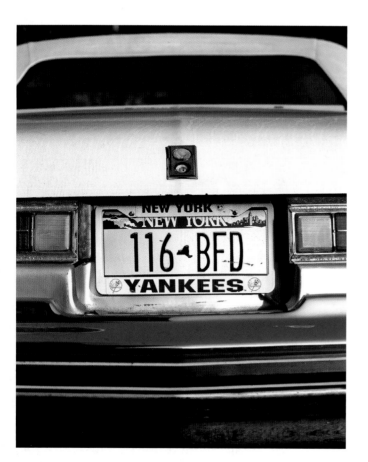

POETIC LICENSE

NOVEMBER 12, 2001

Here's what Yankee fans thought of the Seattle Mariners' 116 regular-season victories after New York beat them in the ALCS.

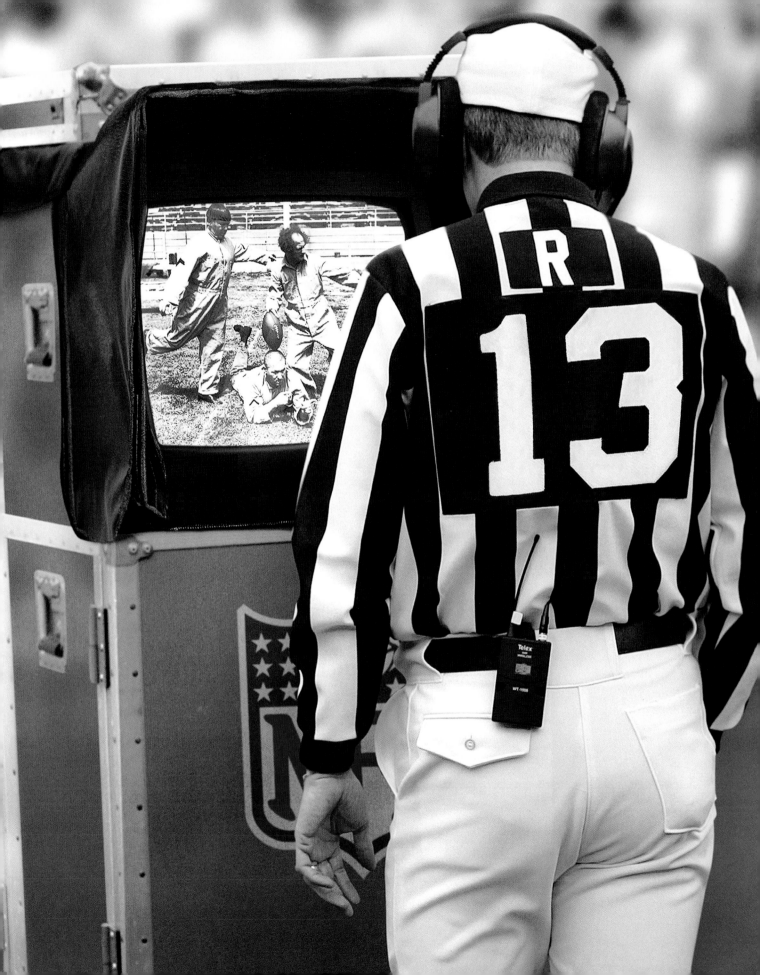

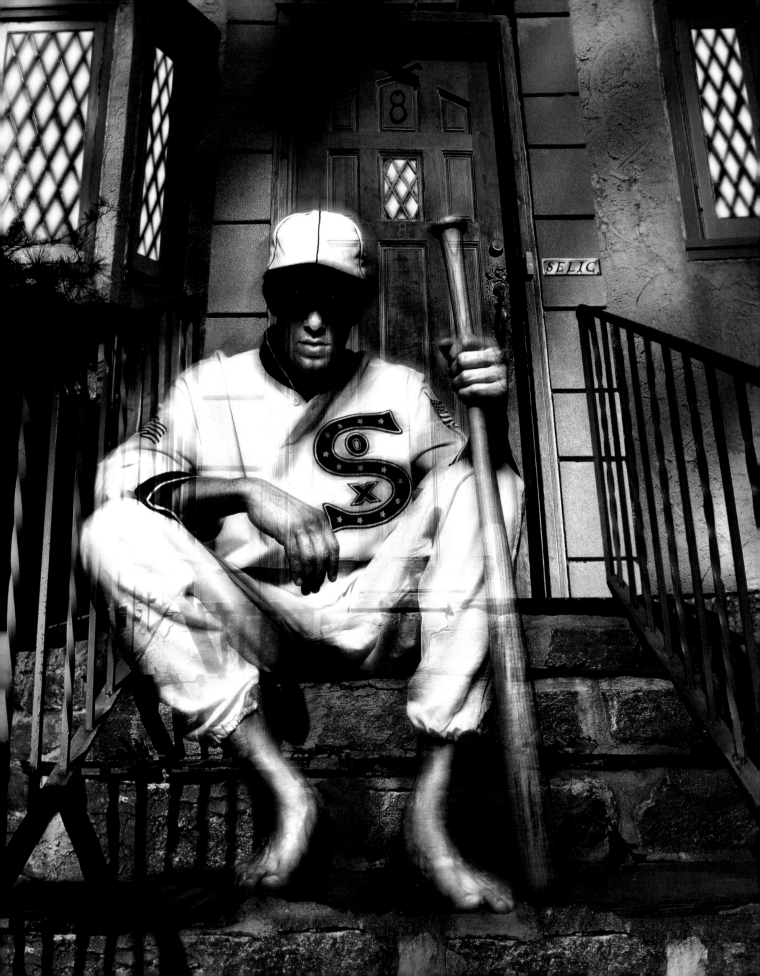

ON DECK?

JANUARY 20, 2003

As Bud Selig pondered whether to put Pete Rose on the Hall of Fame ballot, Shoeless Joe Jackson haunted the commissioner's doorstep.

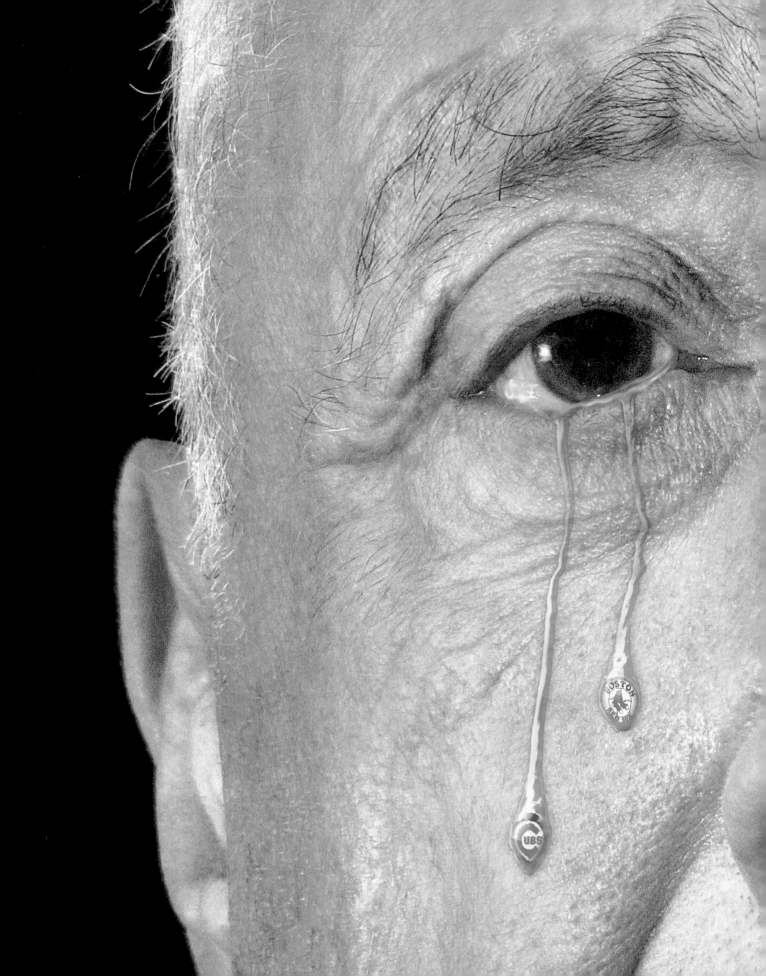

MISERY LOVES COMPANY

NOVEMBER 10, 2003

Tears for two crushing defeats in games that could have ended generations of heartache.

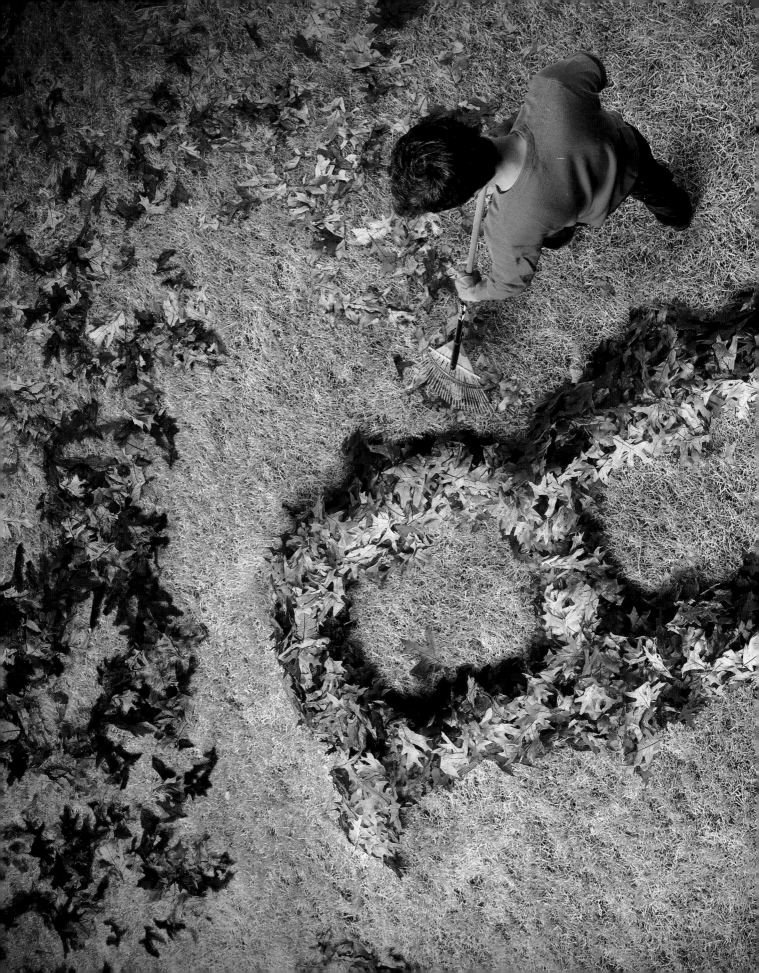

FALL CLASSIC

NOVEMBER 8, 2004

After 86 years, the Boston Red Sox
had finally turned over a new leaf.

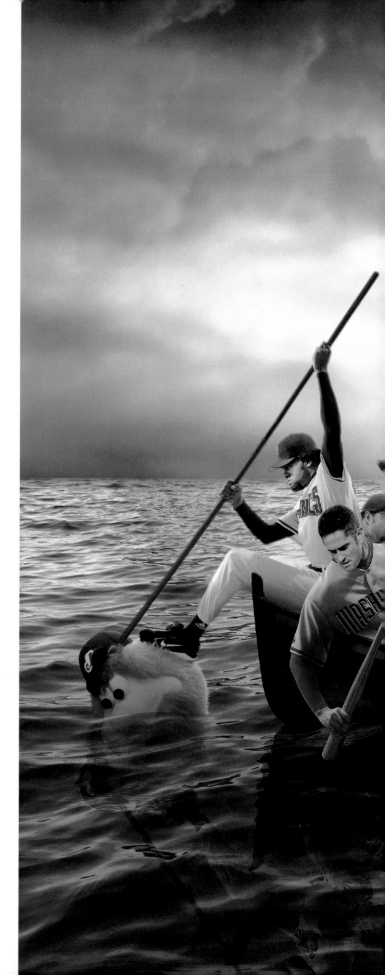

THE CROSSING

JULY 4, 2005

It was the Fourth of July issue, and like George Washington, Nationals field general Frank Robinson was first in … the NL East. As for Youppi, he was literally thrown overboard when the Expos left Montreal.

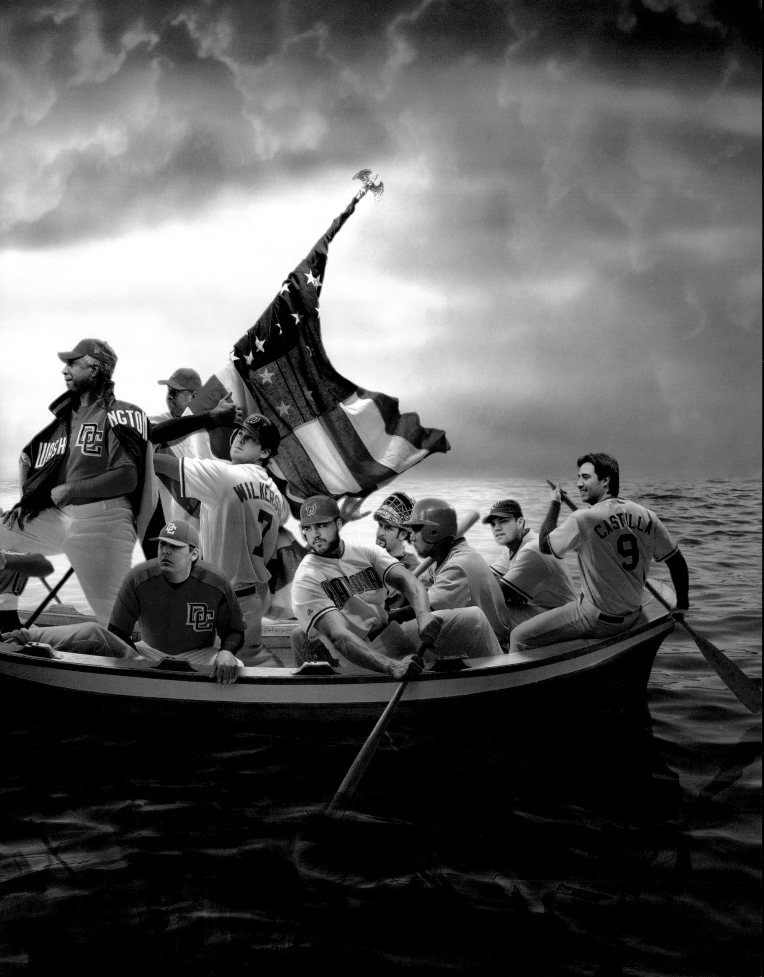

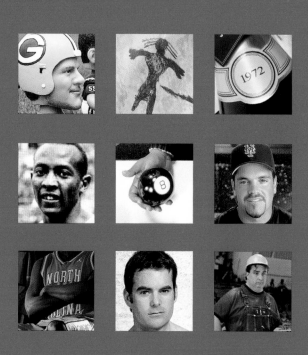

MAIN EVENTS

March Madness, the Olympics, the NFL
draft, the Stanley Cup ... they're all here.
Plus, a few more sports perennials.

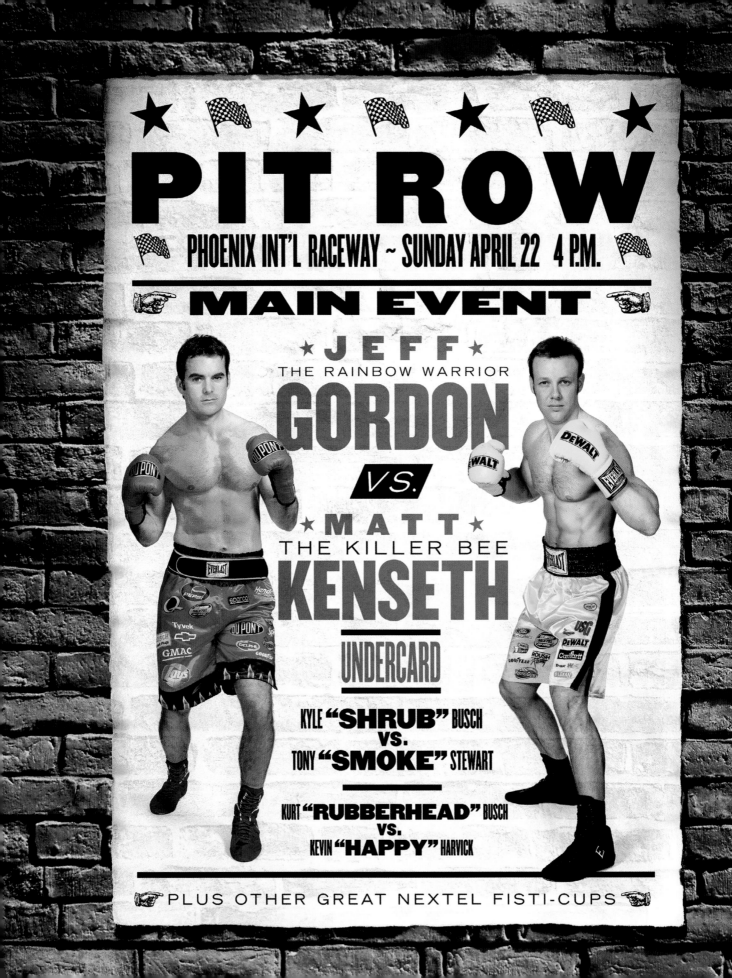

PUNCH IT

APRIL 24, 2006

Road rage can be dangerous at 200 mph,
so why not put all the suddenly pugnacious
Nextel Cup drivers in the ring?

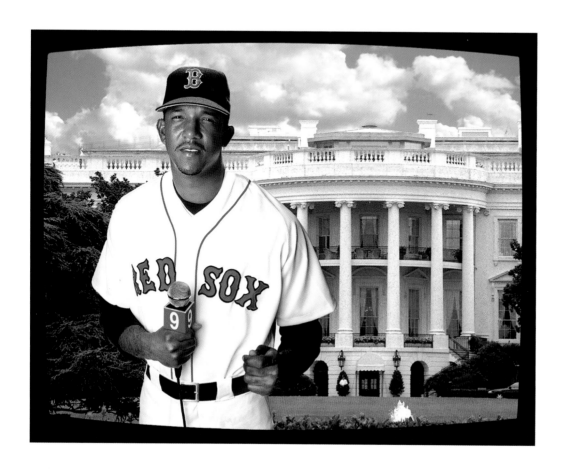

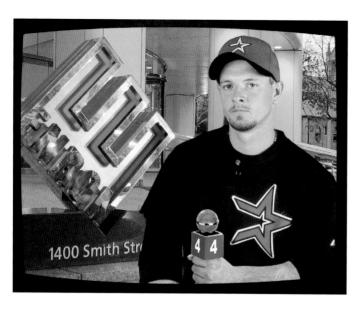

PITCHERS AND CATCHERS REPORT

MARCH 4, 2002

The phrase is music to a baseball fan's ears, but what does it really mean? We asked Pedro Martinez (at the White House), Billy Wagner (at Enron headquarters), Roger Clemens (on the red carpet), Pudge Rodriguez (in Afghanistan), Greg Maddux (doing the weather), and Mike Piazza (in the studio) to find out.

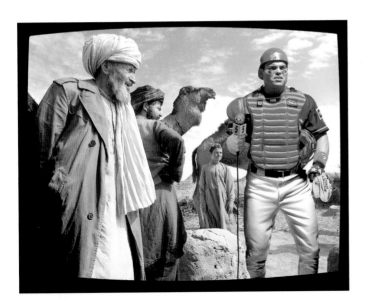

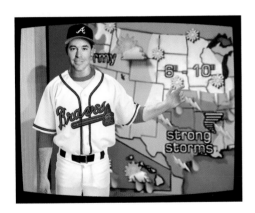

The albatross around Jim Calhoun's neck

The monkey on Roy Williams' back

The albatross around Jim Calhoun's neck

It's a shame one team has to lose

It's a shame one team has to lose

They can taste it

It's a shame one team has to lose

What college basketball is all about

What college basketball is all about

Nobody wants to play them

What college basketball is all about

Big*

Huge

Big

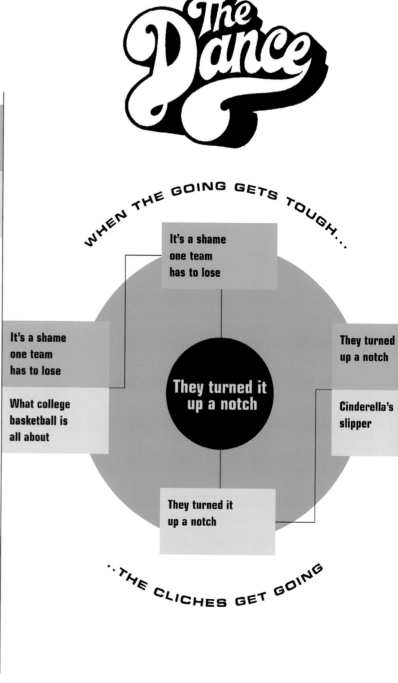

The Dance

WHEN THE GOING GETS TOUGH...

It's a shame one team has to lose

They turned up a notch

They turned it up a notch

Cinderella's slipper

They turned it up a notch

...THE CLICHES GET GOING

*In a huge upset

He's a PTPer!

Awesome, baby!

Awesome, baby!

They turned it
up a notch

They turned it
up a notch

There's no
tomorrow

This year's Valpo

They have to
take it one
game at a time

This year's Valpo

Cinderella's
slipper

Cinderella's
slipper

There's a lot of
basketball left

SWEET SIXTEEN

MARCH 22, 1999

This bracket of Tournament clichés was actually
made into a T-shirt that was passed around to
ESPN employees. Note the Huge loss to Big in
a huge upset.

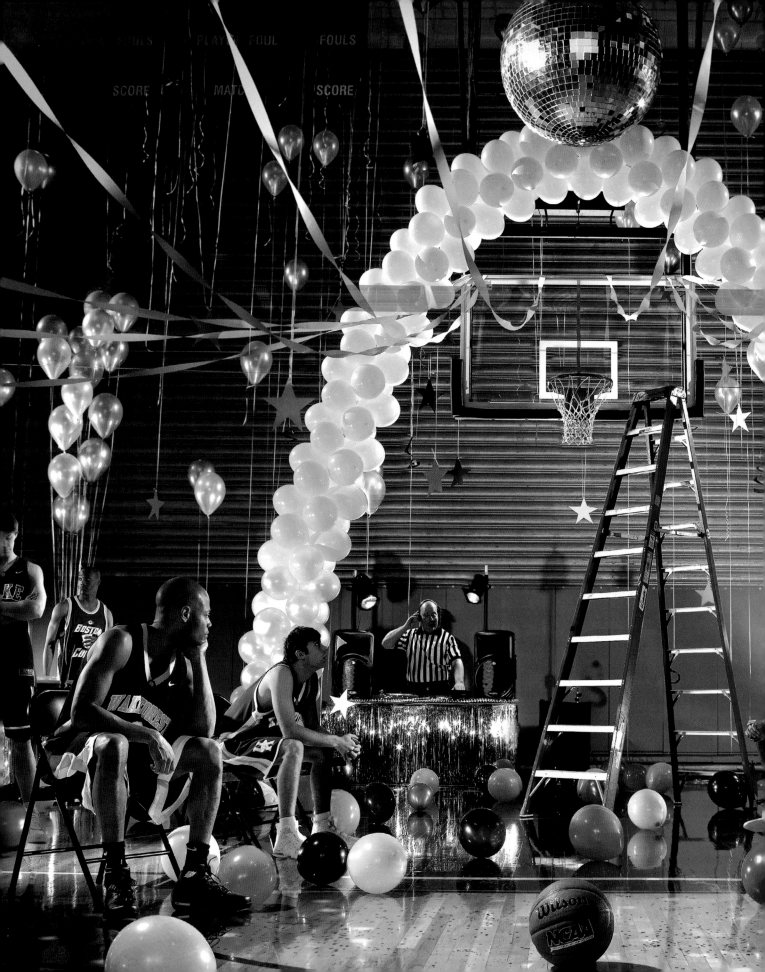

THE BIG DANCE

MARCH 28, 2005

If the NCAA Tournament were actually a prom, this is what it would look like.

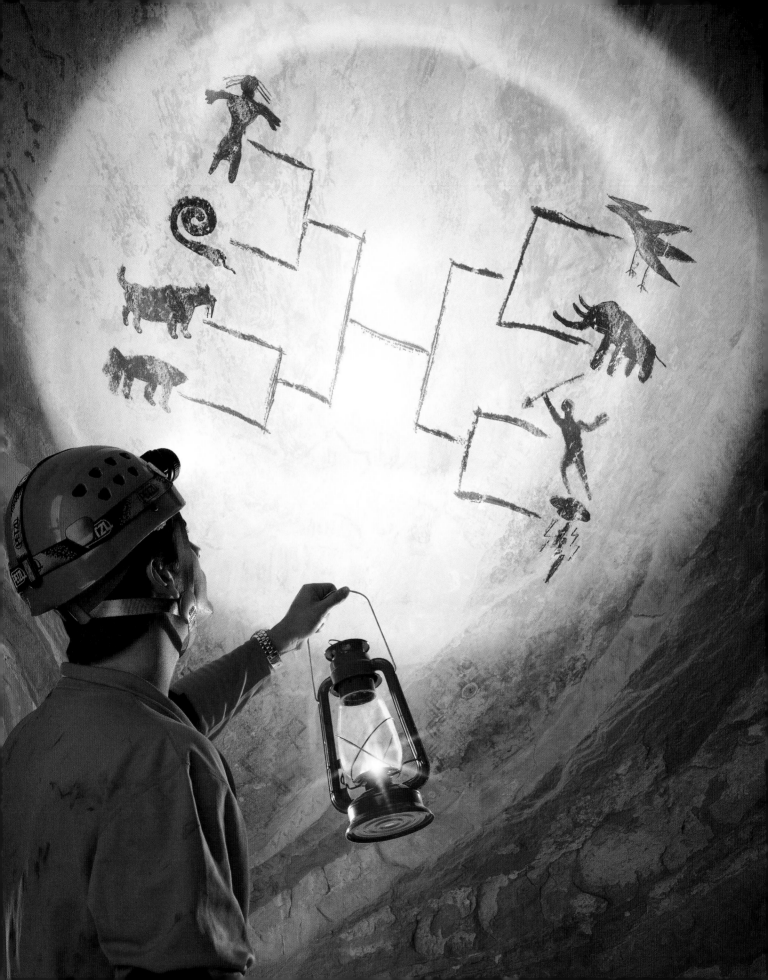

FIRST ROUND

MARCH 27, 2006

Everybody and his brother fills out a bracket, so why not everybody and his ancestor?

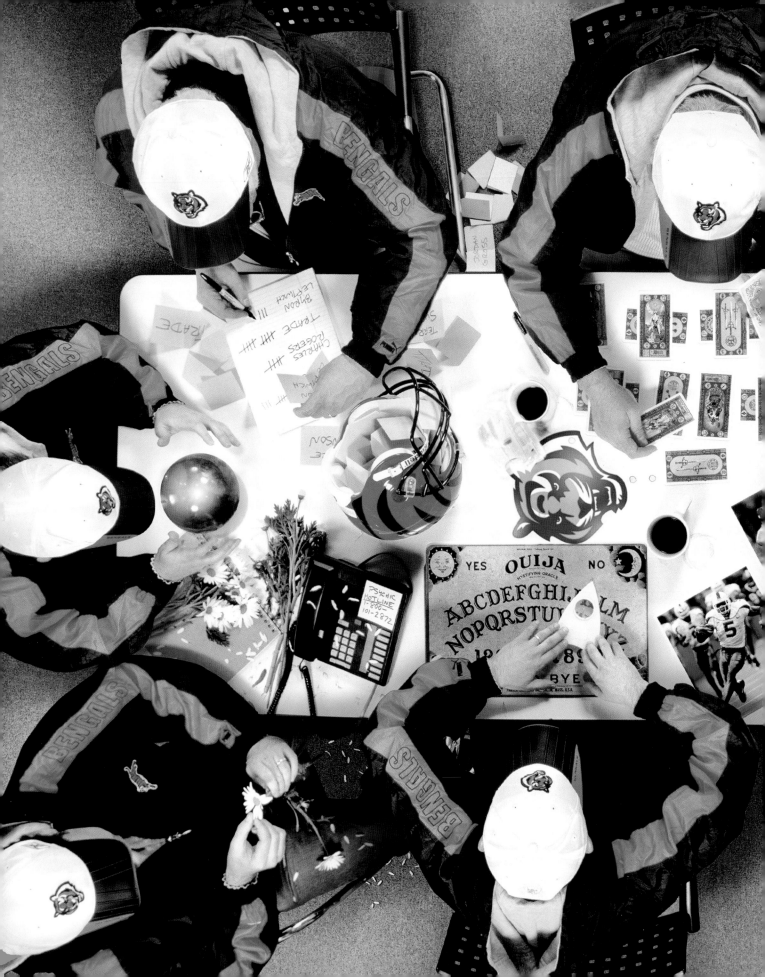

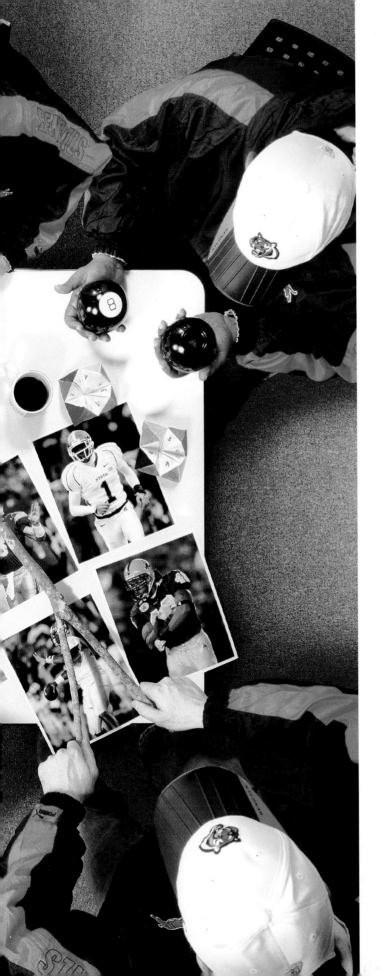

ON THE CLOCK

APRIL 28, 2003

Back then, many fans looked down on the
Cincinnati Bengals' methods of selection in
the NFL draft.

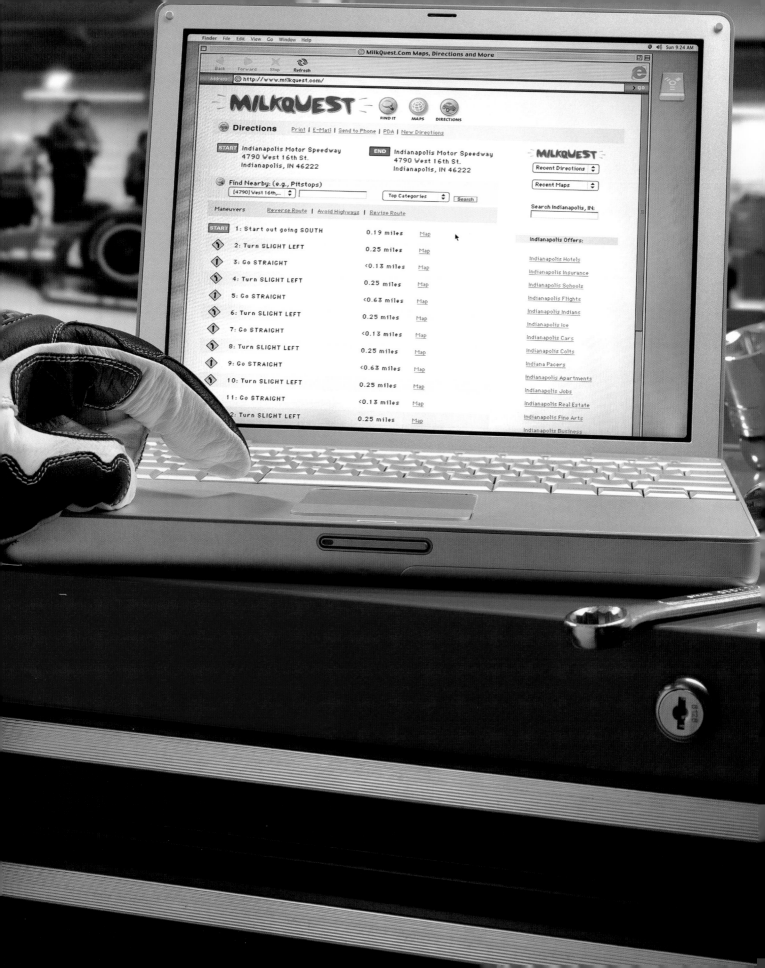

TOTAL DISTANCE: 500 MILES

JUNE 6, 2005

Just in case Indianapolis 500
drivers needed MapQuest ...

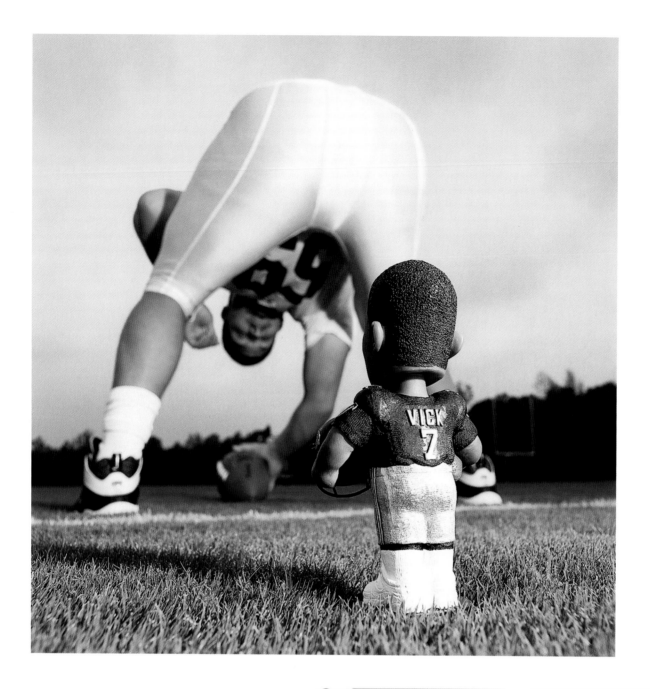

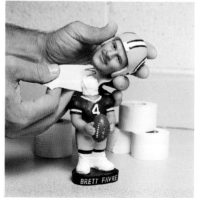

SPECIAL TEAM

SEPTEMBER 3, 2001

NFL training camp can be especially hard on small ceramic figurines with bobbling heads.

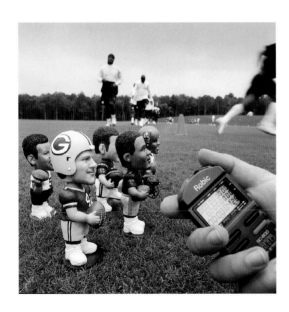

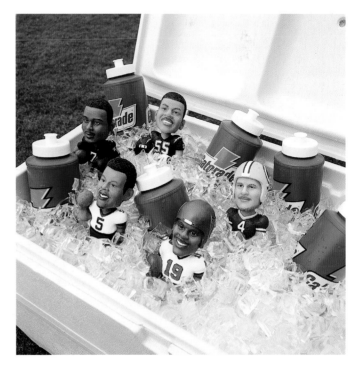

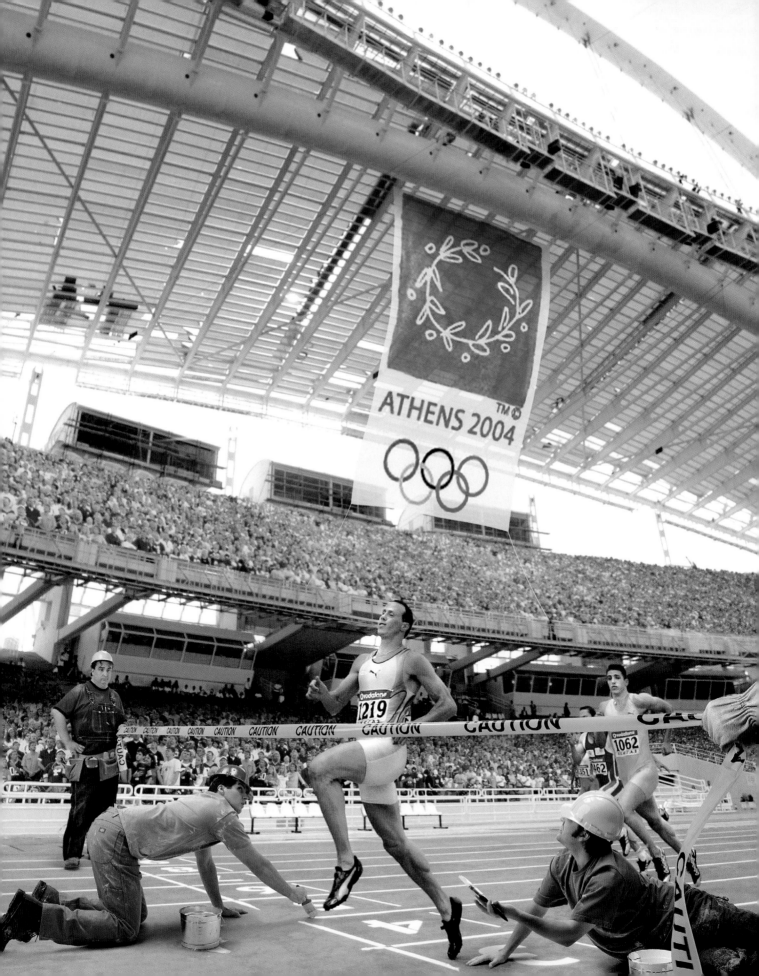

UNFINISHED LINE

AUGUST 2, 2004

At the time this was published, people weren't quite sure the venues in Athens would be ready for the Summer Olympics—a true race to the finish. As it happened, the stadiums were built on time, but the runner chosen for this photo illustration, Kostas Kenteris, never got there because he withdrew from the Games amid a drug testing investigation.

TAPE DELAY

OCTOBER 16, 2000

The gap between event and telecast was so great at the Sydney Games that it only seemed like Jim Gray was interviewing Jesse Owens after the race.

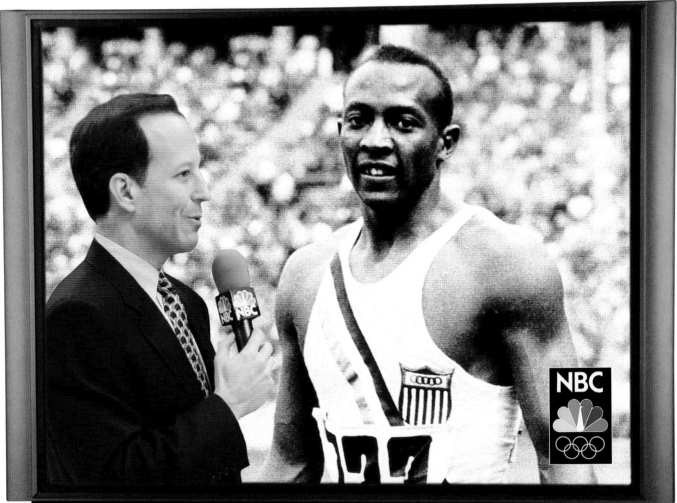

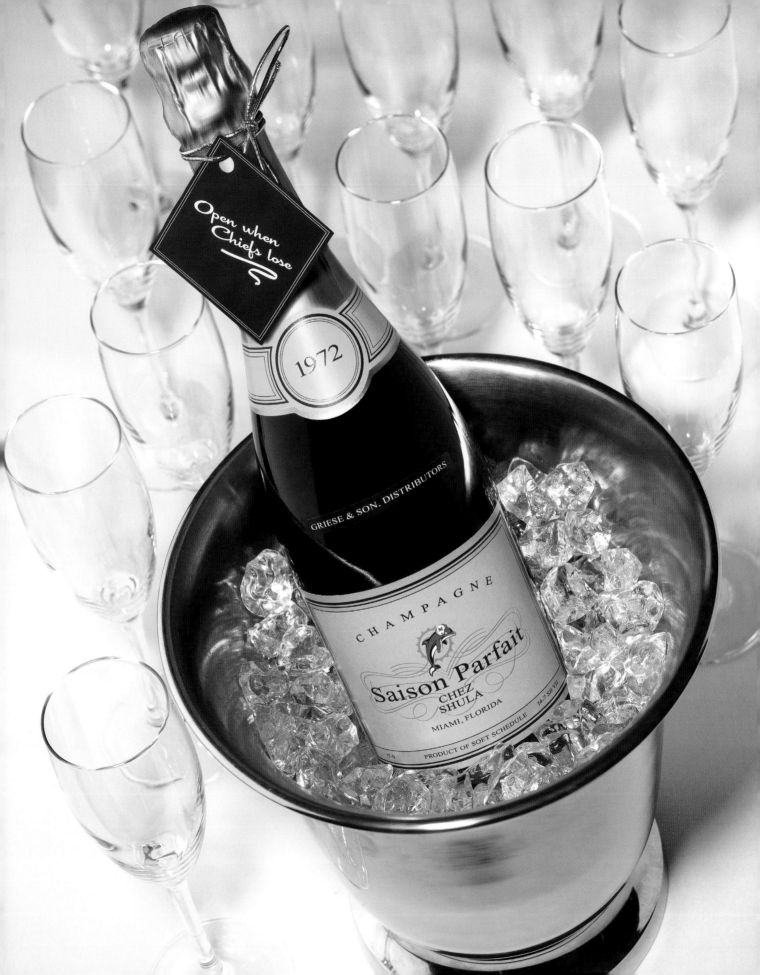

GOES WITH FISH

Every year, it seems, some NFL team like the 2003 Kansas City Chiefs threatens to match the Miami Dolphins' unbeaten 1972 season, and every year, the alumni get together to toast the inevitable defeat. Alternate title: Sour Grapes.

PLAYOFF BEARD

JUNE 5, 2006

Most NHL players stop shaving during the Stanley Cup playoffs. Here's one who took his beard growth to new lengths.

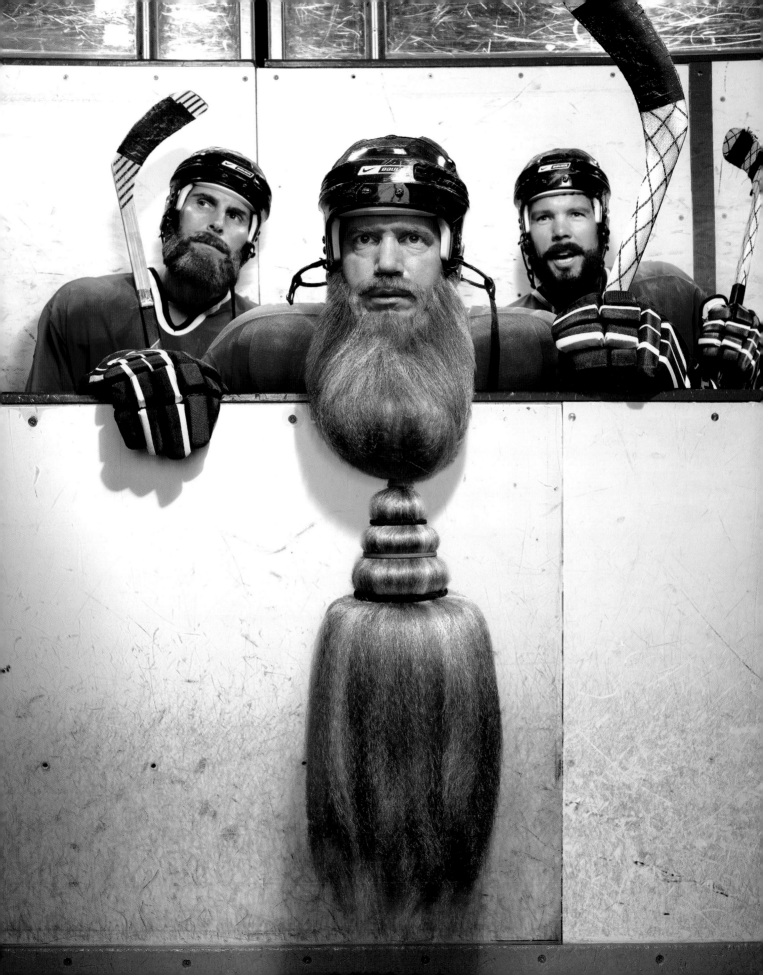

POPCORN

This is not what happens when sports meets popular culture. This is what happens when sports rear-ends culture and they exchange phone numbers and insurance cards.

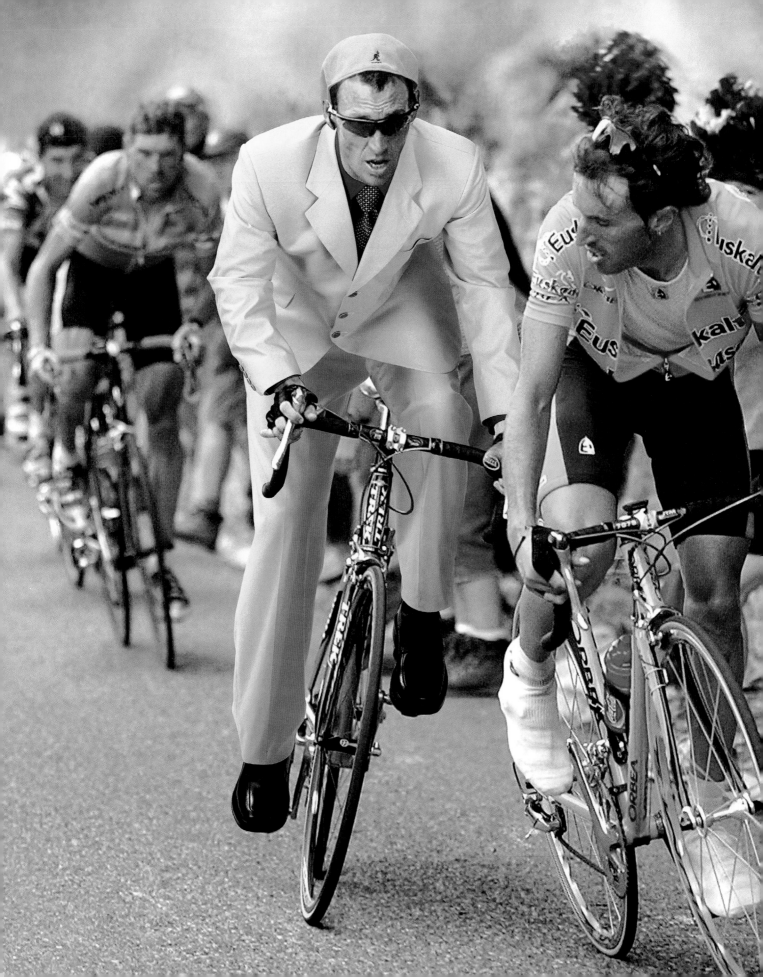

QUEER EYE FOR THE FIVE STRAIGHT GUY

AUGUST 18, 2003

Just as Lance Armstrong was pedaling down the Champs-Élysées for Tour *numéro cinq*, a certain cable makeover show was blowing up.

THE ONE

MAY 26, 2003

On the heels of *The Matrix Reloaded*, Annika Sorenstam took on the men in the Colonial.

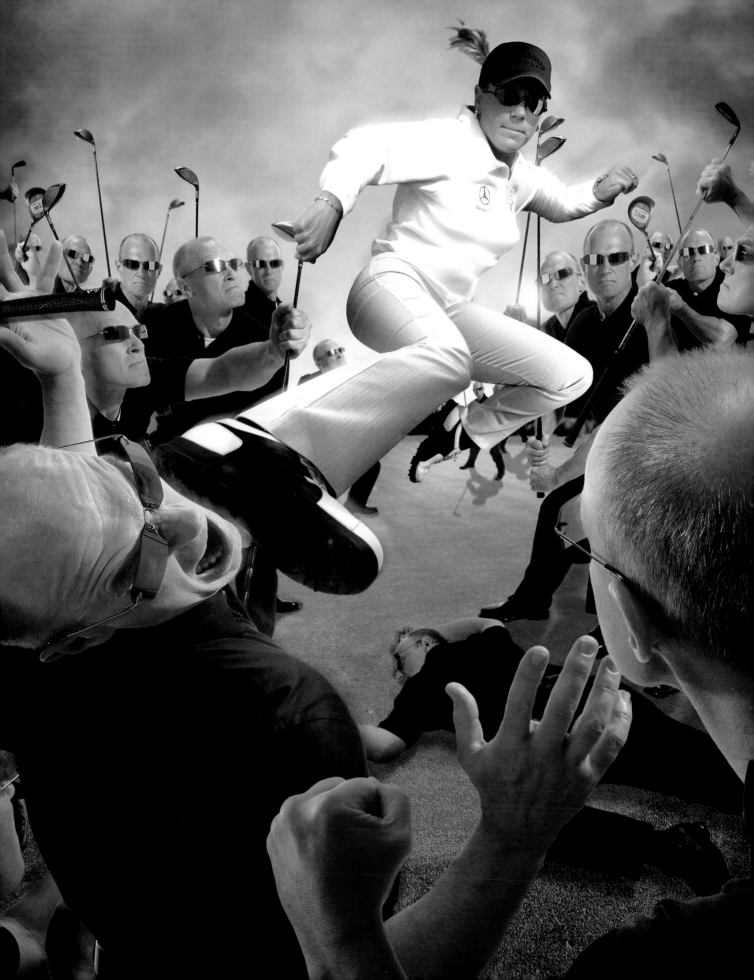

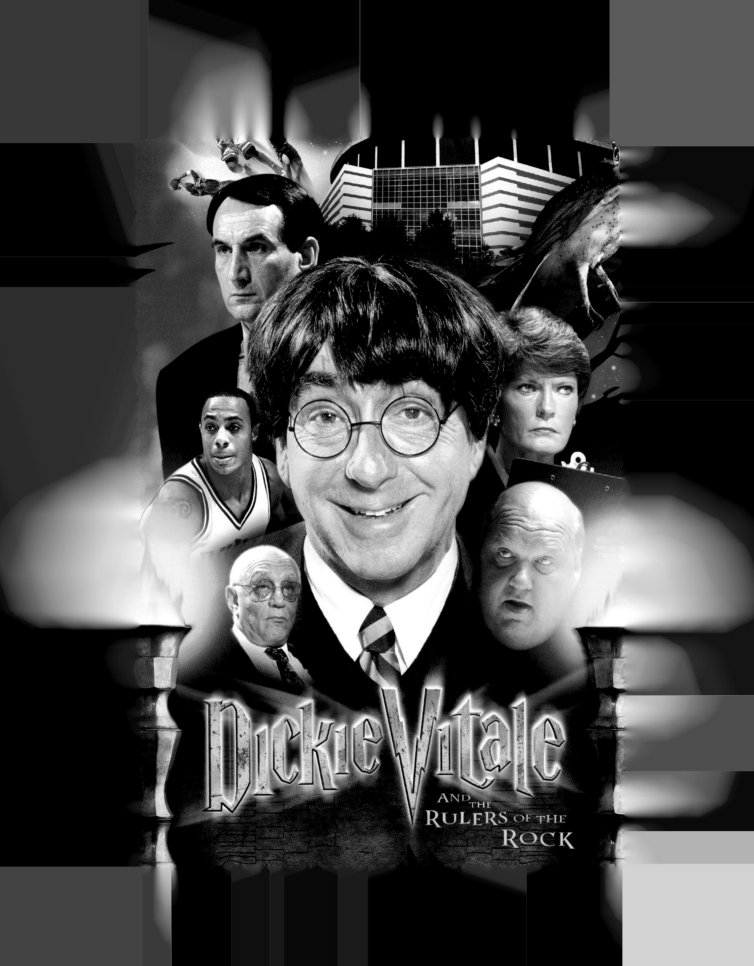

NOW PLAYING

John Wooden was known as the Wizard of Westwood. Dick Vitale? He embodied the magic of the upcoming college basketball season.

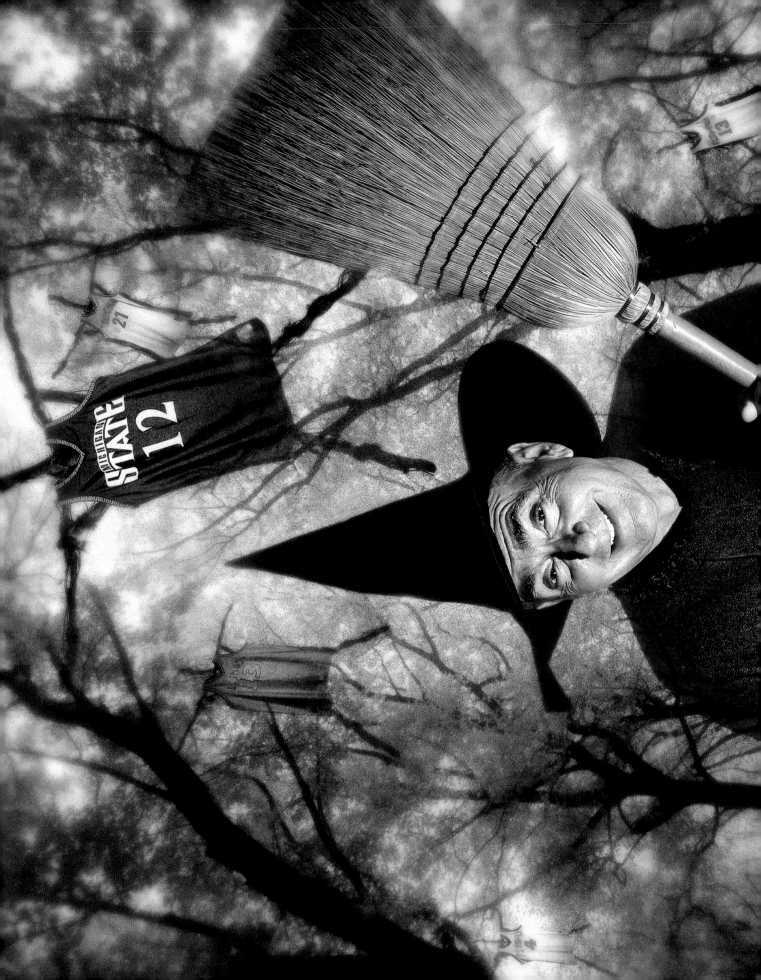

V-WITCHED

NOVEMBER 29, 1999

If you think we could get Dickie V to do pretty much anything, you're right. *The Blair Witch Project* was big at the time.

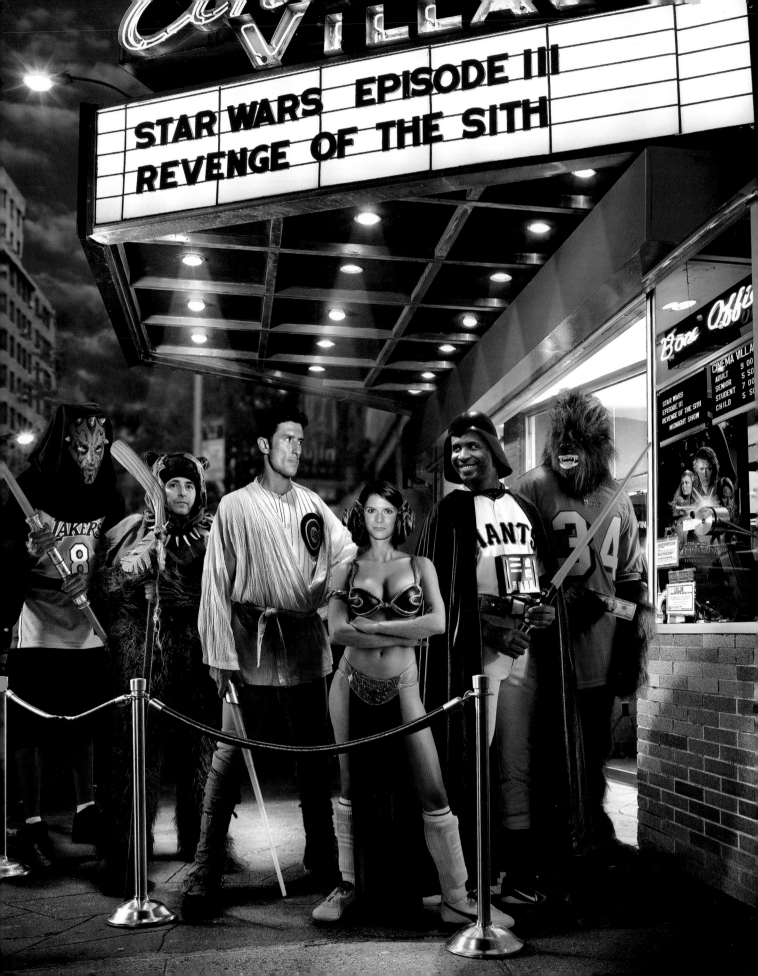

PLAYING WOOKIE

MAY 23, 2005

Who didn't want to stand in line for the last *Star Wars* installment? But it wasn't easy. The costume designer for this photo illustration featuring idle sports figures made a Princess Leia outfit according to the measurements provided by a model. But when she showed up to play Mia Hamm, it was apparent that she had undergone breast enhancement. "She kept apologizing," said Aaron Goodman. "And we kept saying that it was okay."

KEN BURNS'
UTAH JAZZ

FEBRUARY 5, 2001

Get it? Well, if you don't, you're in good company.
This was actually shown to Ken Burns right after
it—and his PBS *Jazz* series—came out, and Burns
didn't recognize that the quintet behind Louis
Armstrong was Utah's starting five.

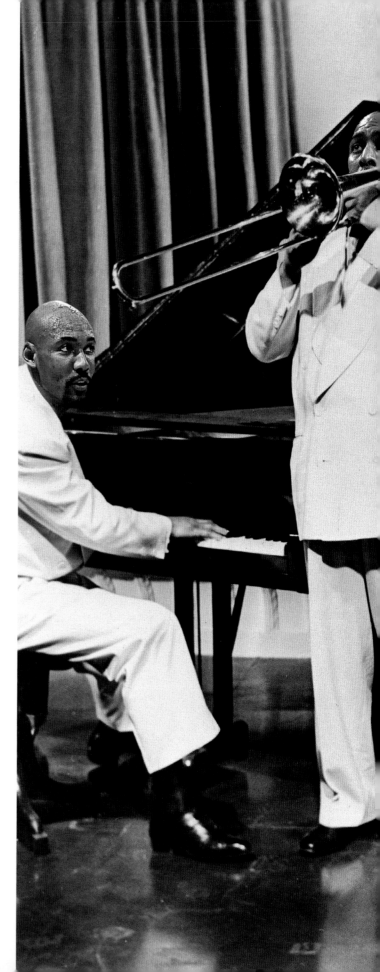

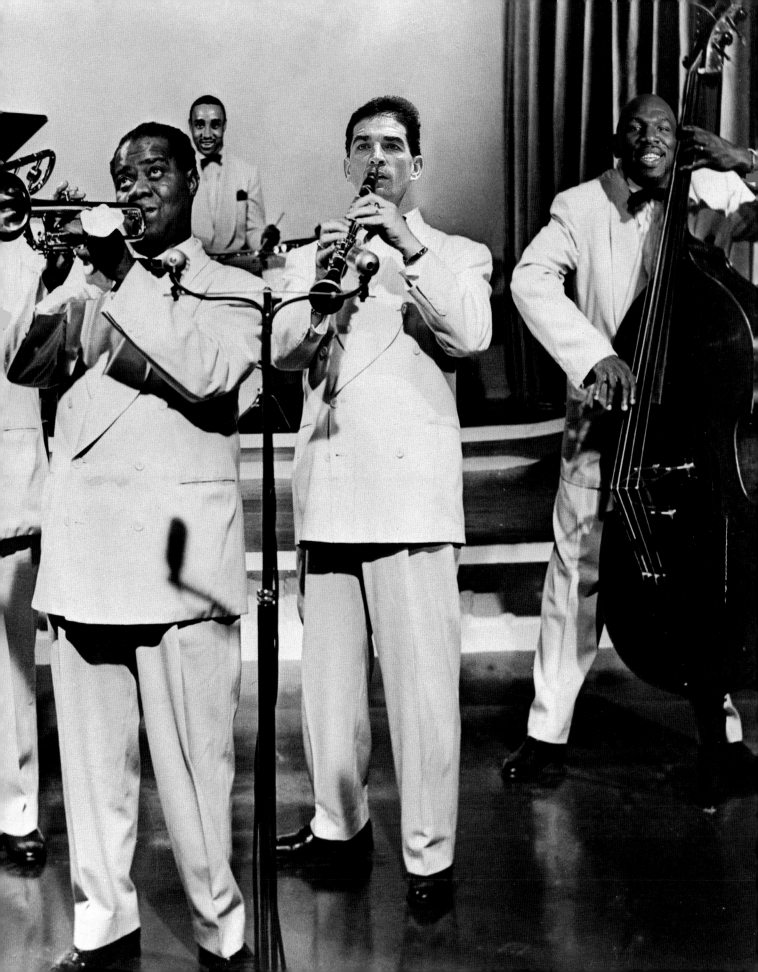

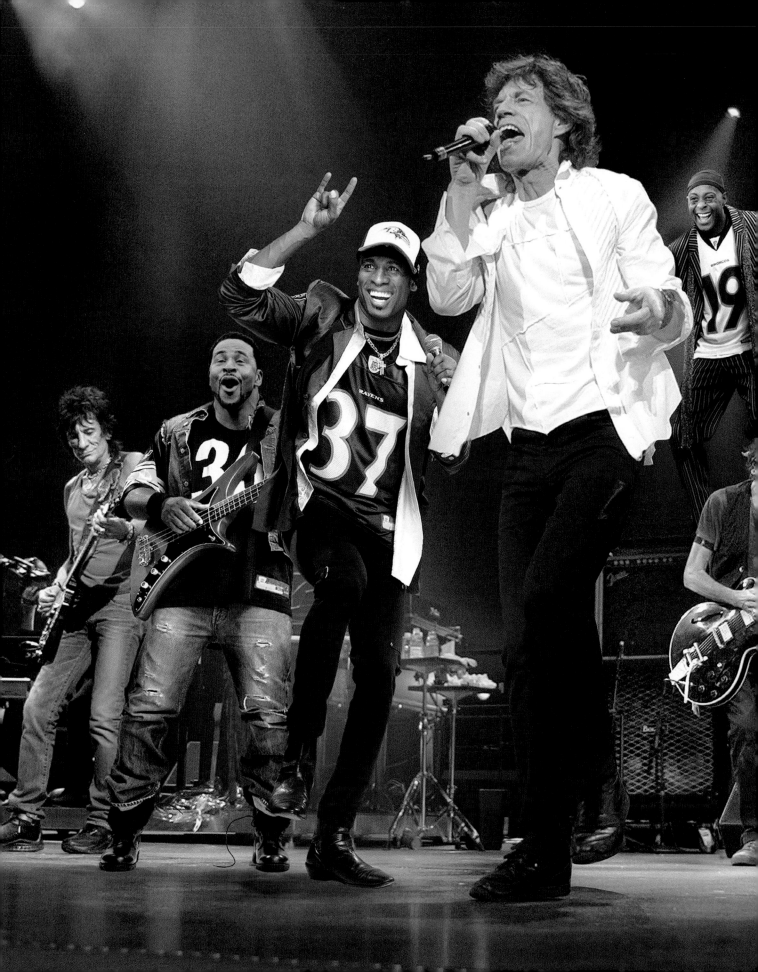

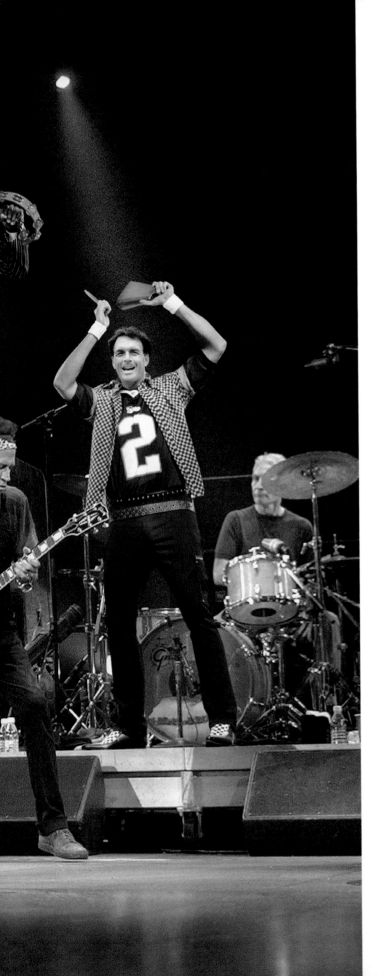

CLASSIC ROCK

SEPTEMBER 12, 2005

The NFL was counting on the Rolling Stones for its season opener, and several teams were counting on some other aging stars: Jerome Bettis, Deion Sanders, Jerry Rice, and Doug Flutie.

CHECK IT OUT

MAY 12, 2003

You had to be there—on the checkout line at the grocery store, thumbing through the *Weekly World News*—to fully appreciate this attempt at hilarity.

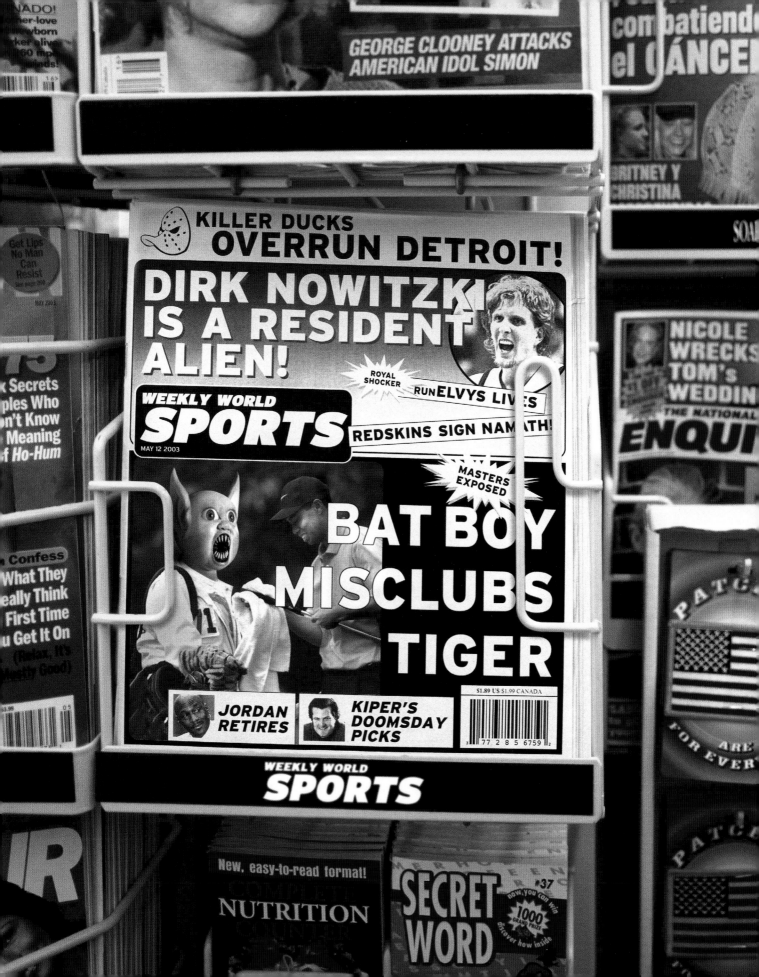

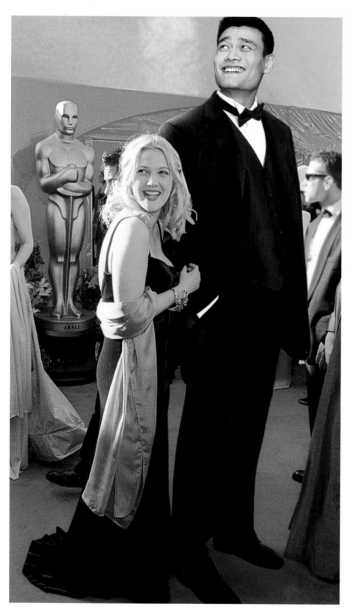

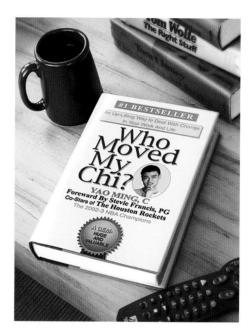

#1 BESTSELLER

An Up-Lifting Way to Deal With Change
In Your Work And Life

Who Moved My Chi?

YAO MING, C
Foreward By Stevie Francis, PG
Co-Stars of The Houston Rockets
The 2002-3 NBA Champions

A GEM!
HUGE AND
VALUABLE

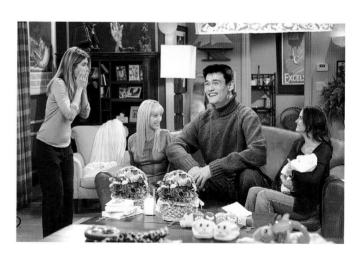

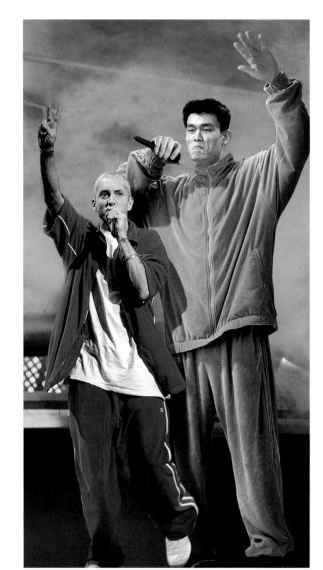

YAO DA MAN

FEBRUARY 17, 2003

Mingmania was in full swing, and the sky was the limit for the 7'5" Yao's next career moves.

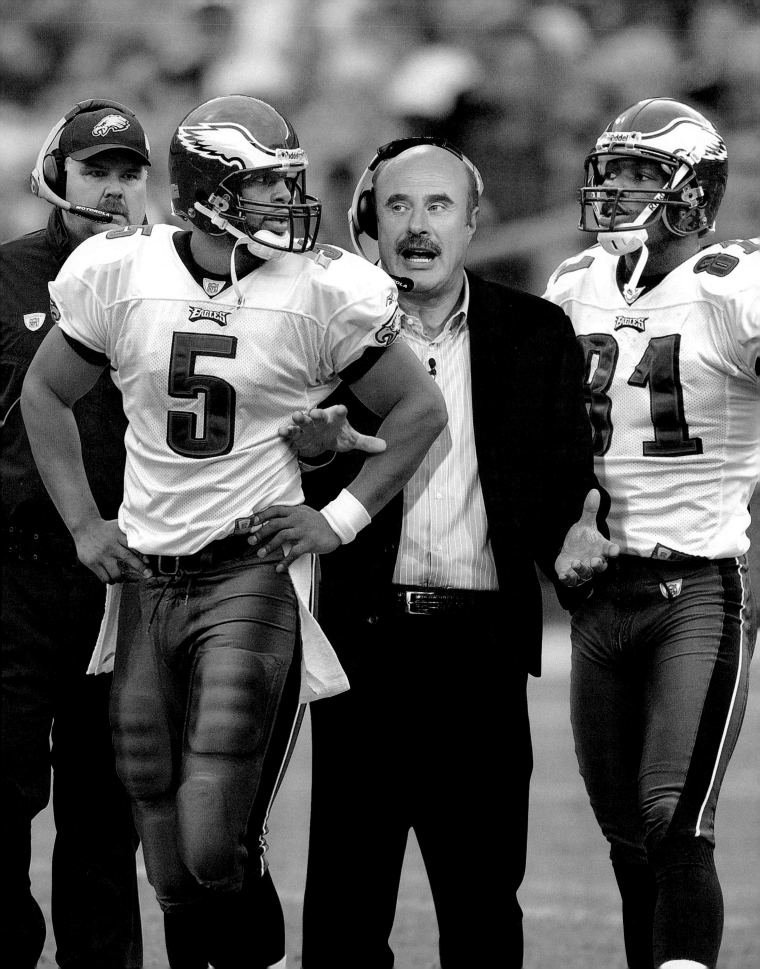

DR. PHILLY

SEPTEMBER 26, 2005

What's wrong with this picture? Well, if you really follow Dr. Phil McGraw, you know that he's 6'4", which means he should be taller than squabbling teammates Donovan McNabb and Terrell Owens.

CINDERELLA MAN

MARCH 13, 2006

A BEAUTIFUL MIND

APRIL 1, 2002

THE AVIATOR

FEBRUARY 28, 2005

The tradition of turning a sports figure into an Oscar-like statuette began when Dennis Rodman was gilded in 1999. In subsequent years, attempts were made to link those figures to both Oscar-nominated films and actual categories. Missing from this spread are "Great in Traffic" (Allen Iverson, 2001), "The Two Towers" (Kobe Bryant and Tracy McGrady, 2003), and "Big Fish" (Jack McKeon, 2004).

LATIN AMERICAN BEAUTY

APRIL 3, 2000

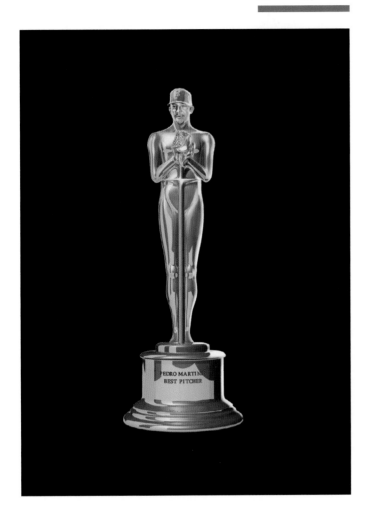

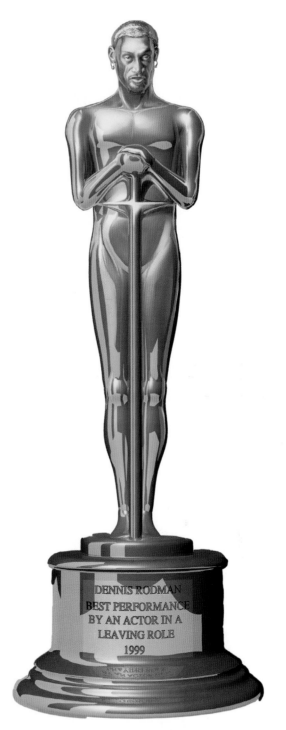

HOLLYWOOD ICON

APRIL 5, 1999

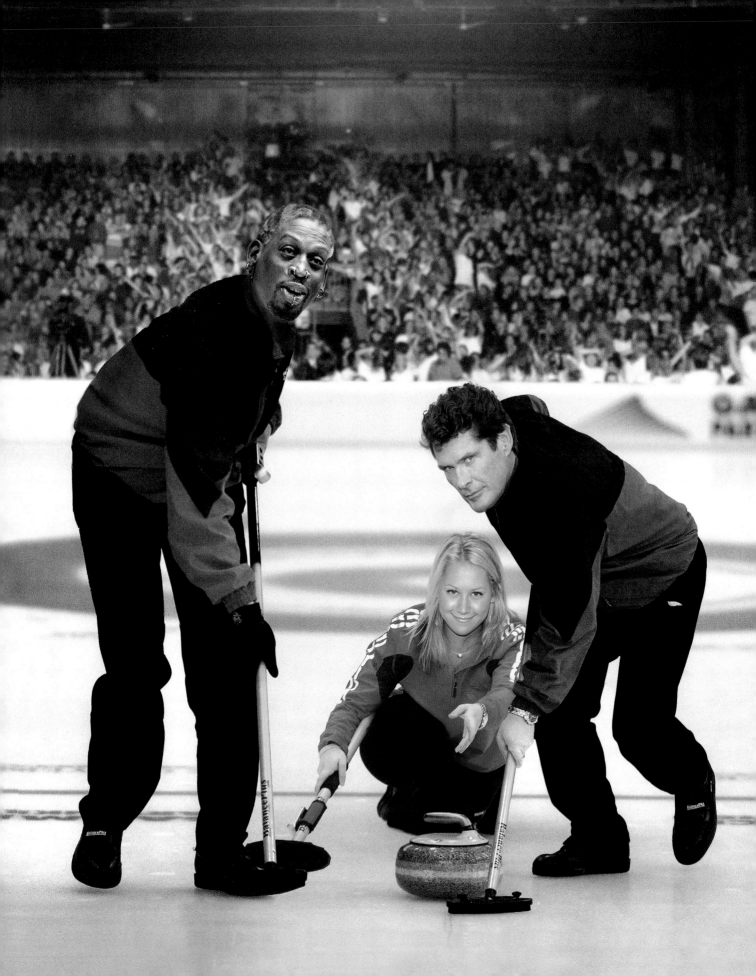

CURLING WITH THE STARS

FEBRUARY 27, 2006

For those who liked *Dancing With the Stars*, *Skating With Celebrities,* and NBC's coverage of the Torino Winter Games, here was just the show, starring Dennis Rodman, Anna Kournikova, and David Hasselhoff.

IT'S A MYSTERY

MAY 8, 2006

The paperback of *The Da Vinci Code* had just come out and nobody had a clue as to where Vince Young would go in the NFL draft.

0:00

You know those e-mails you wrote but
never sent, the biting remarks you
thought of too late, the brilliant ideas
you had that were squashed by fate?
Well, here are some of the 0:01s that
never ran—for several reasons.

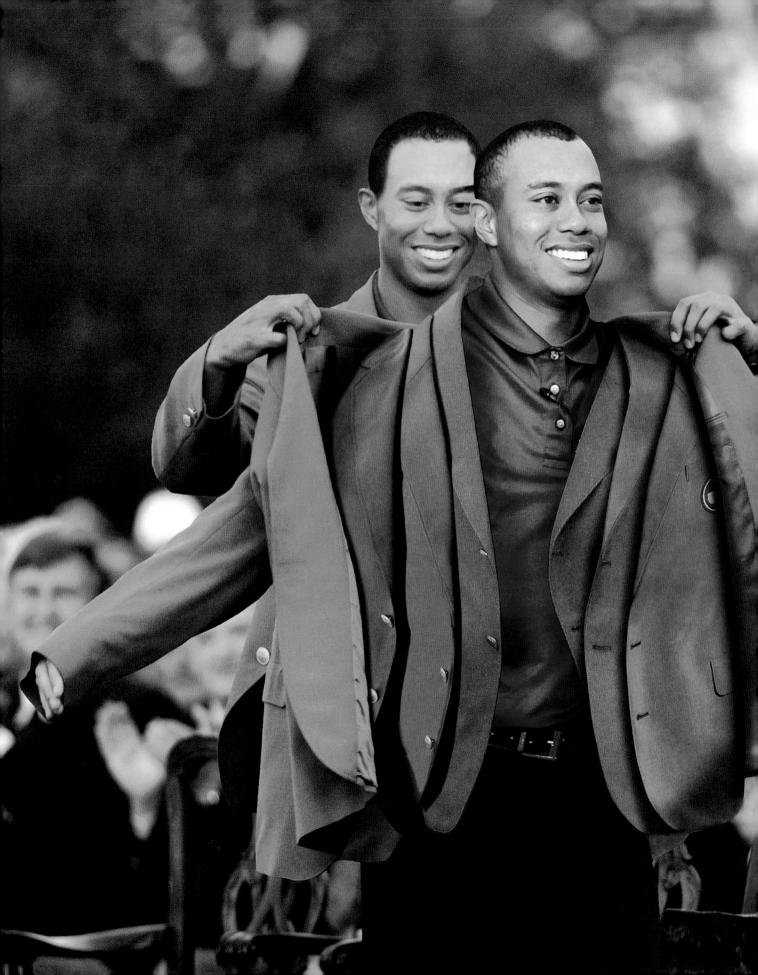

GREENSLEEVES

With the possibility of Tiger Woods' winning a fifth Masters—his second in a row—this could easily have been the scene at the 18th green at Augusta National. But just before press time, the health of Tiger's dad took a turn for the worse, so a mulligan was taken.

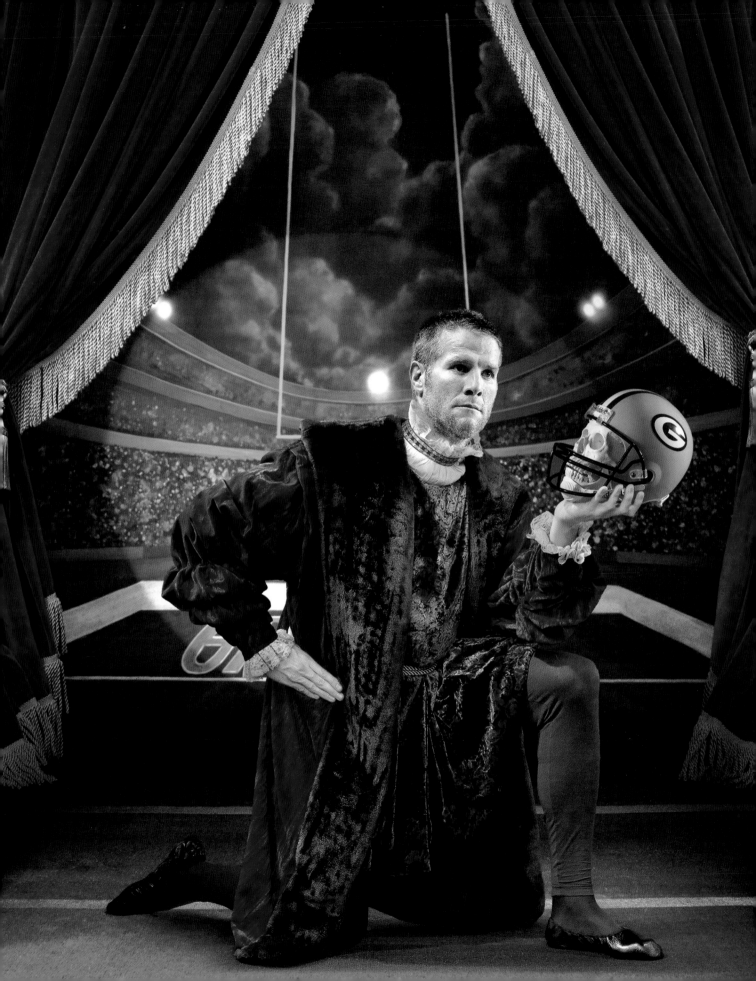

QB OR NOT QB

Brett Favre's indecision in the spring of 2006 was growing tiresome, but no sooner had the King of Green Bay been cast as the Prince of Denmark than he finally decided "to take arms against a sea of troubles" and come back for another season.

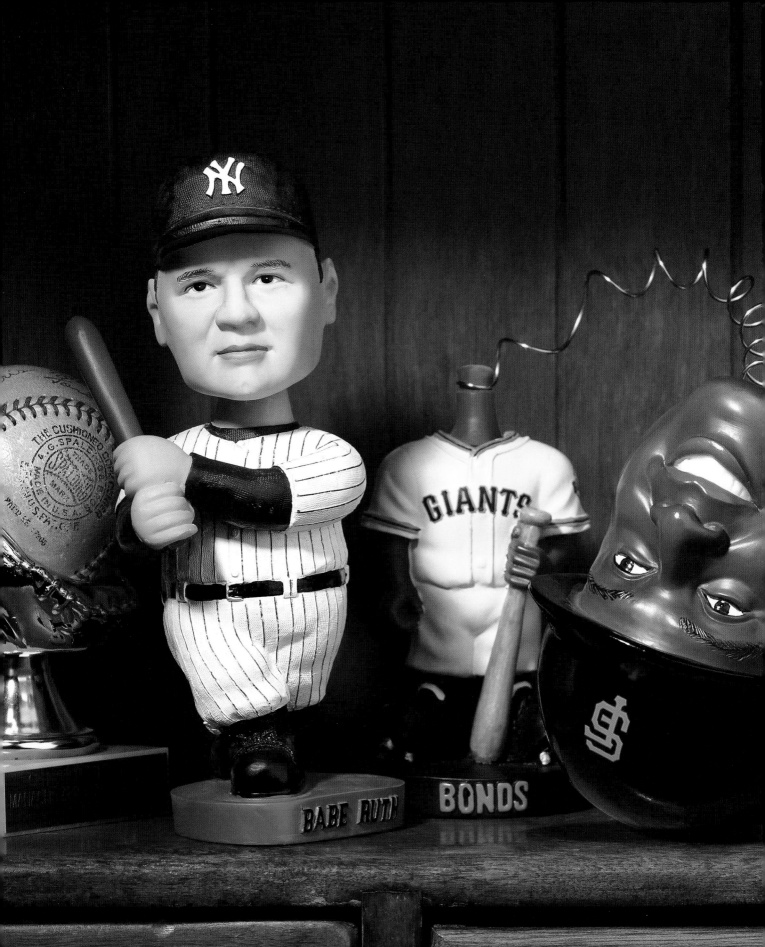

OVERHEAD

One thing that distinguishes Barry Bonds from the legendary figures who now bookend him on the career home run list is his somewhat larger noggin size.

ABOUT THE AUTHORS

Steve Wulf is the co-author (with Daniel Okrent) of the best-seller *Baseball Anecdotes*, as well as the co-author of *I Was Right On Time*, the autobiography of Negro Leagues legend Buck O'Neil. A founding editor of *ESPN The Magazine*, Wulf has also been on the staff of *Time* and *Sports Illustrated*, and written for *Entertainment Weekly*, *Life*, *The Wall Street Journal*, and *The Economist*. A father of four, he can be found at various rinks, diamonds, fields, stables, and courts in Westchester County, N.Y.

Mike Greenberg is co-host of *Mike and Mike in the Morning* on ESPN Radio and an anchor on ESPN's *SportsCenter*. A graduate of the Medill School of Journalism at Northwestern University, he is the author of the New York Times best-seller *Why My Wife Thinks I'm an Idiot*.

CREDITS